ICONS

NATIVE AMERICANS

DIE INDIANER
NORDAMERIKAS

LES INDIENS
D'AMÉRIQUE DU NORD

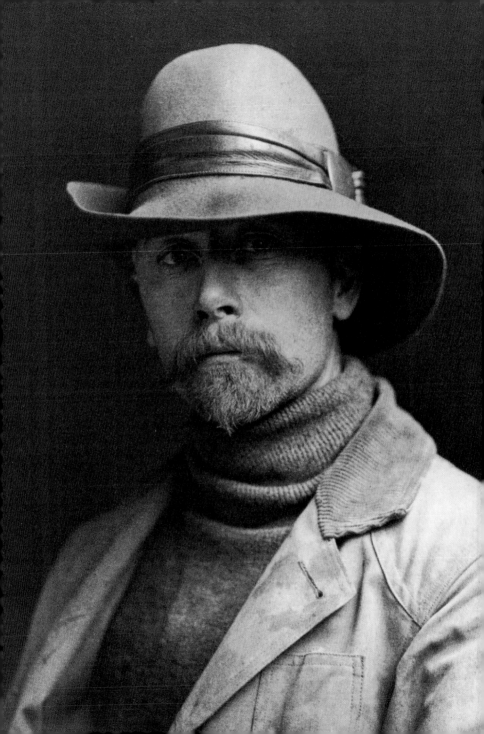

HANS CHRISTIAN ADAM

NATIVE AMERICANS

DIE INDIANER NORDAMERIKAS

LES INDIENS D'AMÉRIQUE DU NORD

EDWARD S. CURTIS

TASCHEN

KÖLN LONDON MADRID NEW YORK PARIS TOKYO

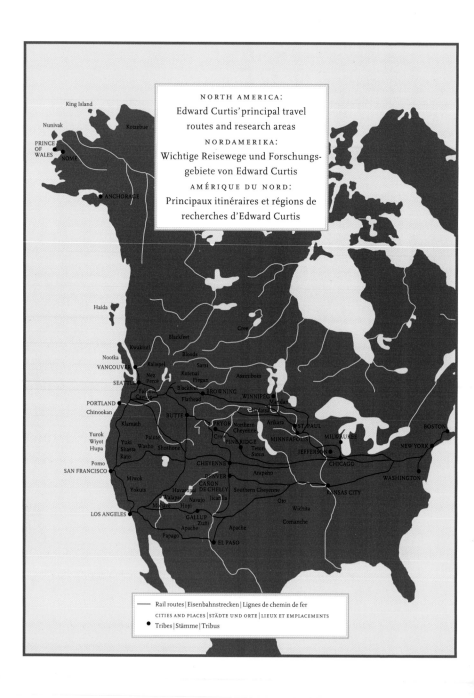

NORTH AMERICA:
Edward Curtis' principal travel
routes and research areas
NORDAMERIKA:
Wichtige Reisewege und Forschungs-
gebiete von Edward Curtis
AMÉRIQUE DU NORD:
Principaux itinéraires et régions de
recherches d'Edward Curtis

King Island
Nunivak
Kotzebue
PRINCE
OF
WALES NOME
ANCHORAGE

Haida

Cree
Blackfeet
Kwakiutl
Bloods
Nootka Kalispel Sarsi
VANCOUVER Nez Kutenai Assiniboin
Perce Piegan
SEATTLE Yakima Blackfoot BROWNING
Cayuse WINNIPEG Mandan
PORTLAND Flathead Matua
Chinookan BUTTE Arikara
Klamath PRYOR Northern ST. PAUL
Paiute Cheyenne MINNEAPOLIS MILWAUKEE BOSTON
Yurok Yuki Crow PINERIDGE NEW YORK
Wiyot Shasta Washo Shoshone Teton JEFFERS CHICAGO
Hupa Kato Sioux
Pomo CHEYENNE WASHINGTON
SAN FRANCISCO Miwok Arapaho
Yokus DENVER
Havasupai CAÑON KANSAS CITY
Walapai DE CHELLY Southern Cheyenne
Mohave Navajo Jicarilla Oto
LOS ANGELES Hopi Wichita
GALLUP Comanche
Zuni
Apache Apache
Papago
EL PASO

—— Rail routes | Eisenbahnstrecken | Lignes de chemin de fer
CITIES AND PLACES | STÄDTE UND ORTE | LIEUX ET EMPLACEMENTS
● Tribes | Stämme | Tribus

Contents
Inhalt
Sommaire

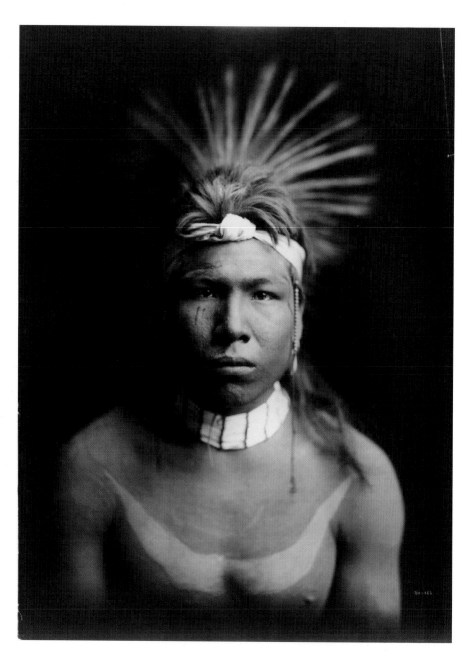

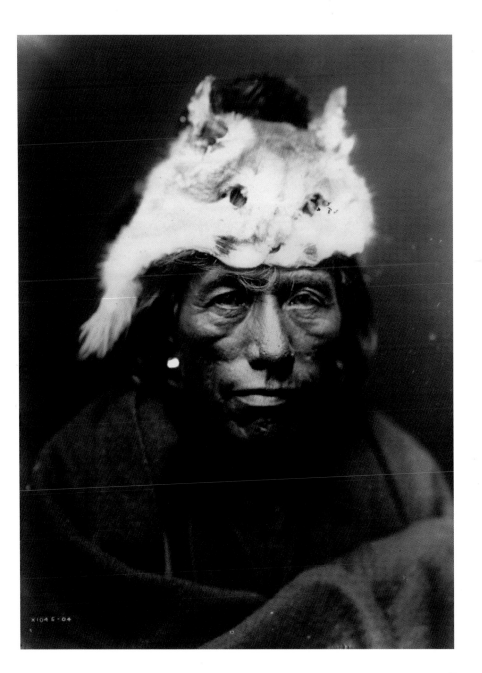

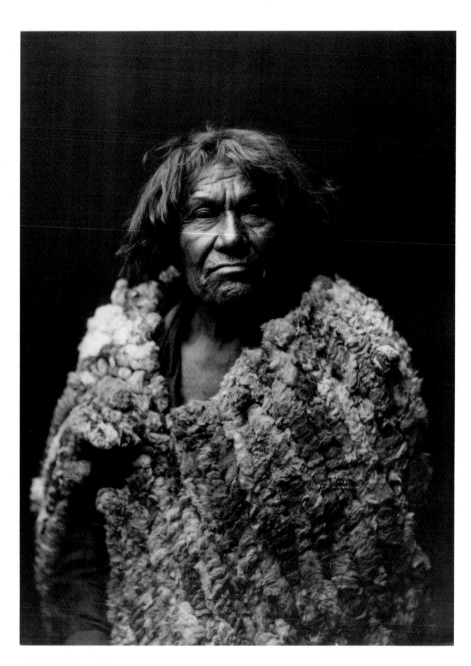

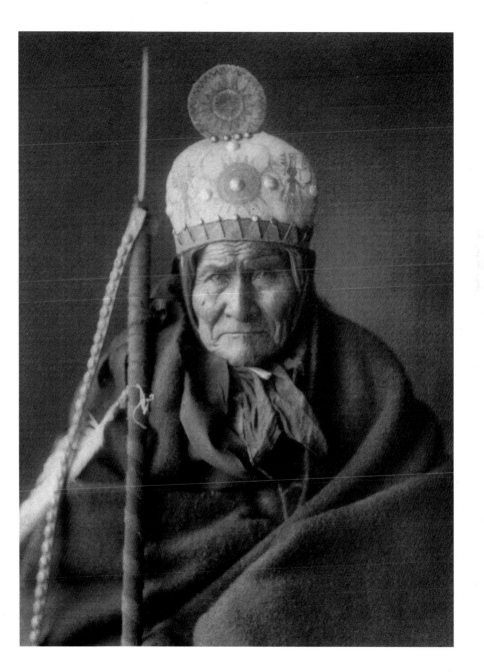

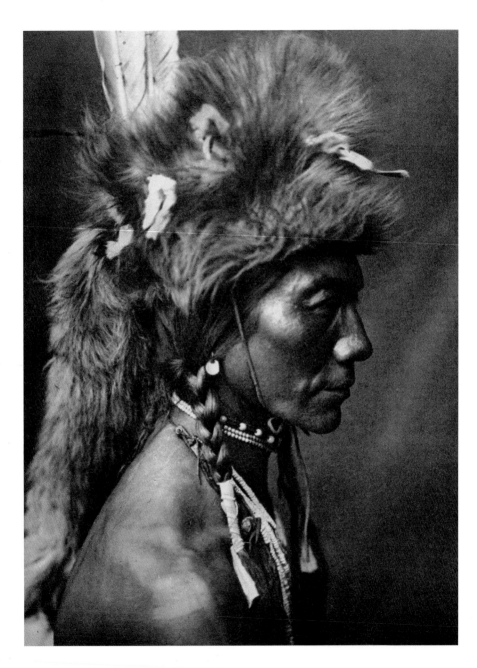

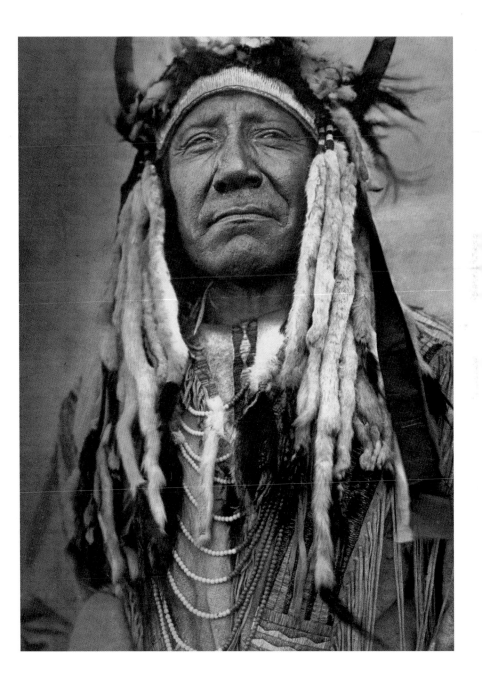

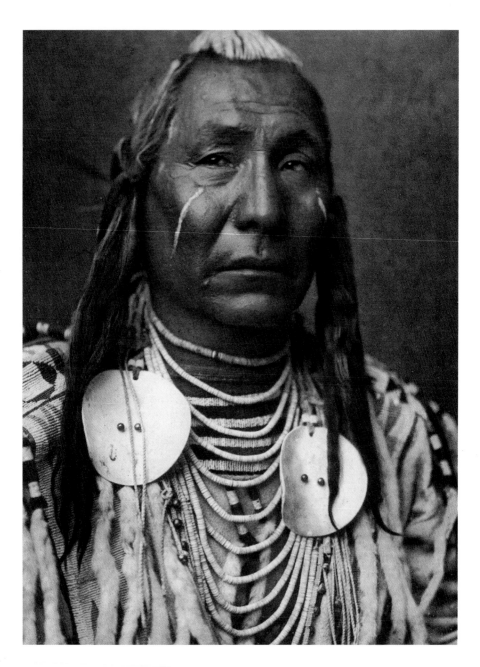

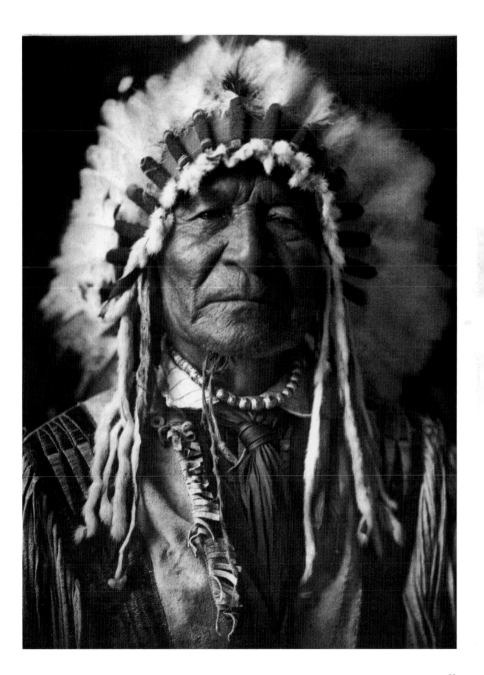

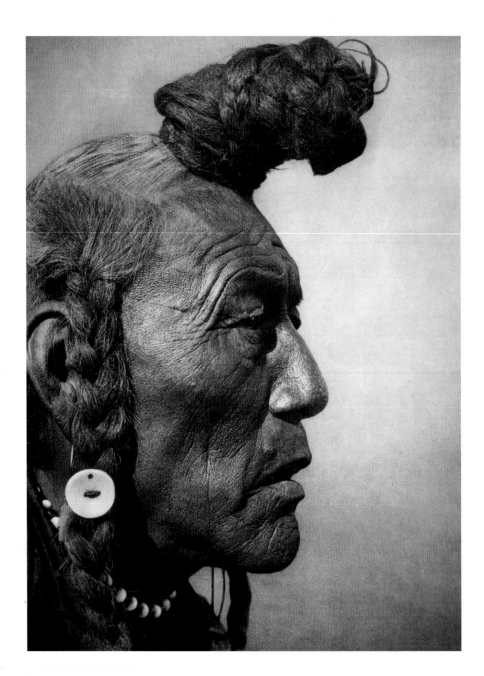

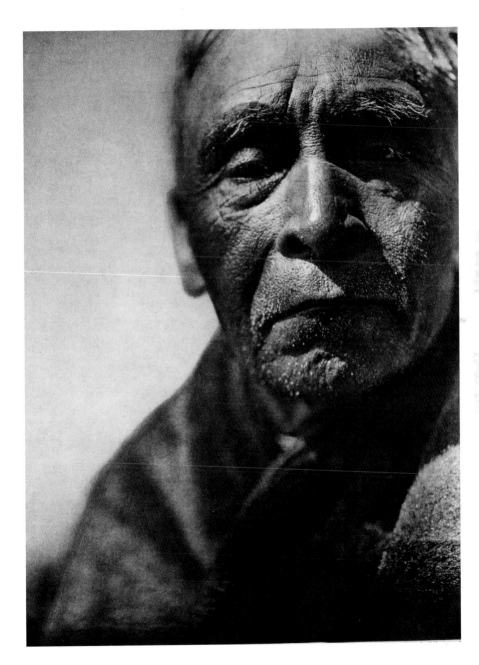

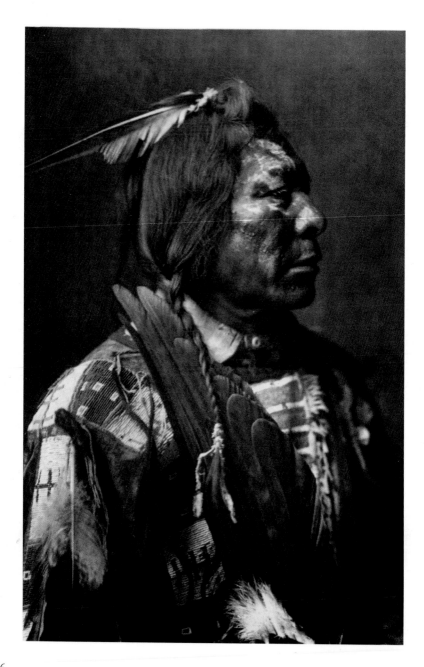

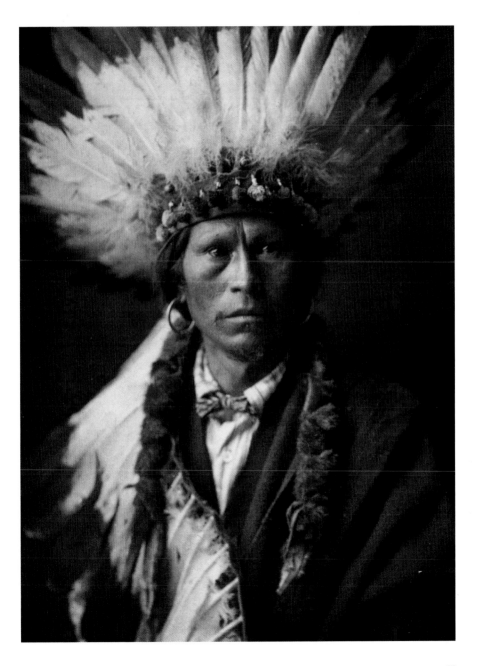

In search of lost time

Edward S. Curtis and
the North American Indians

Whenever we open a book or magazine or pass a billboard and see an old-fashioned-looking black-and-white photo of a lone "Red Indian" on the wide open prairie, or a chieftain wearing a feather headdress, or a squaw before a tipi, the chances are that the photographer was Edward Sheriff Curtis (1868–1952). His photographic œuvre not only ties in with our traditional idea of the North American Indian, but has largely moulded this notion. Curtis' photographs show Indians as they might once have been – or, rather, as we might wish them to have been.

No other photographer has created a larger body of pictures on this subject. Starting at the turn of the 19th/20th centuries, Curtis dedicated over 30 years to his goal of capturing the last lived traditions of the Indian tribes in word and image. He spent the greater part of his life studying their life and customs, and noting down their history and their legends, with the result that Curtis the photographer also became an ethnographer.

His many years of endeavour culminated in the 20-volume encyclopaedia *The North American Indian*, which comprised extensive textual material and some 2,200 photogravures. The work was issued in a very limited print run between 1907 and 1930, the set costing a princely 3,000 dollars. The encyclopaedia covers the entire American continent north of the Mexican border and west of the Mississippi, and constitutes one of the most important historical publications on American Indians. It is also one of the most beautiful books ever produced, superlatively printed on heavy paper, leather-bound and with gilt edging. Each of the 20 self-contained volumes, which were illustrated with approximately 75 plates measuring 14 x 19 cm (5" x 7") and which featured the occasional chart or map, was dedicated to one or a number of related or topographically contiguous Indian tribes in North America. Each individual volume was further accompanied by a separate portfolio, which generally contained 36 large-format photo-

gravures, measuring approximately 30 x 40 cm (12" x 16"). These photogravures were also sold in a separate edition of offprints, and it is especially on these top-quality prints, the highlights of which are showcased in this book, that Curtis' reputation as a photographer rests. Curtis' fame peaked between 1905 and 1914, but by the time the last volume of his encyclopaedia appeared in 1930, he was known to only a handful of specialists.

Coming from a modest background, Edward Sheriff Curtis was born in 1868 on a farm in Wisconsin. His father, an invalid from the Civil War, was an itinerant preacher, and sometimes the young Edward would accompany him on rides lasting several days through the prairies, as a result of which he became acquainted early on with life under the open sky. The boy went to school for only six years. It seems that he took an interest in photography, in a self-taught capacity at an early age, subsequently working as an apprentice in a photo studio in St. Paul. Following the early death of the father, the family settled in Seattle in the state of Washington. Here in 1897, after a number of attempts, Curtis managed to open a photo studio of his own, specialising in portrait photography, and his business soon flourished. Famous personalities came to his studio to sit for him, including the Russian ballerina Anna Pavlova (1881–1931) and the winner of the Nobel Prize for literature Rabindranath Tagore (1861–1941).

Curtis had begun photographing in the environs of Seattle around 1890, taking shots for example of the Indians at nearby Puget Sound or of the landscape of Mount Rainier. He knew this wilderness so well that he sometimes worked in it as a mountain guide. In 1898 he came by chance to the aid of a group of scientists who had lost their way in the mountains, an encounter that was to radically alter his life. For the contact led to a highly interesting commission for Curtis: to accompany the private Alaska expedition of the railway magnate Edward Harriman the following year as tour photographer. During the trip Curtis got to know some prominent American scientists, in particular striking up a close relationship with the ethnographer and expert on American Indians George Bird Grinnell (1849–1938). As early as 1900 the two mounted a joint expedition to Montana, where Curtis had the opportunity to live among the Indians and photograph them. After participating in the Harriman expedition, Curtis' witnessing of the sun dance of the Blood, Blackfoot and Algonquin tribes proved to be a second turning point in the photographer's life.

Despite his growing fascination for the Indians, Curtis knew little about them at first, and initially he shared the whites' prejudice that their religion was nothing

but senseless superstition with no deeper meaning. Yet the desire had been kindled in him to learn more about the individual tribes. For his first photographs he asked Indians to restage famous battles or conduct ceremonies for him, attempting to erase all signs of assimilation on the part of the Indians to the culture of the white man. His Indian models, who mostly lived on the reservations, happily posed for Curtis' camera, as if they too wanted to recapture their past – that seemingly carefree everyday existence and profound spirituality that the white man had taken from them.

The idea of creating an extensive documentation of the traditional ways of the Northern American Indian tribes came to Curtis around 1903. He conceived of the plan of capturing in word and image the history of all of the Indian tribes, their life, ceremonies, legends and myths. The areas he wished to investigate were language, social and political organization, geographical context, living conditions, dress, procurement and preparation of food, weights and measures, religious customs, the rituals and customs pertaining to birth, marriage and death, as well as games, music and dance.

In the years up to 1928 Curtis visited more than 80 Indian tribes. To do justice to his self-imposed task, he had for years on end to photograph in both heat and cold, in drought and in deep snow. He also had to contend with the trying job of winning over the Indians to his purpose.

Through both ignorance and inquisitiveness, Curtis at first unwittingly broke a number of unwritten laws and was correspondingly coolly received by the tribes. Although with time Curtis learned a number of Indian languages, it seemed to him advantageous – not least in view of his early blunders – to have a member of the tribe at his side as an adviser and informant. Over the years the photographer won the trust and friendship of the Indians, who for their part came increasingly to appreciate him as the chronicler of their traditions. Since the North American Indian peoples had no written lore, Curtis directed his attention to their oral traditions. He noted down the biographies of prominent chieftains, warriors, medicine men and priests, and with the help of an early sound-recording device also captured the Indians' music. As his researches were coming to an end, it happened that tribes which for years he had vainly tried to contact sent word that they would now be glad to receive him. They had realized that Curtis and his assistants were the only people who wished to document their traditions in word and picture.

Although Curtis' Indian pictures were already well-known in the first years of the 20th century, the photographer was unable to fund his ambitious documen-

tary project solely from the sales of his photographs. Thus it was an extremely fortunate circumstance that President Theodore Roosevelt should come to know of Curtis' work and introduce the photographer to the financier John Pierpont Morgan (1837–1913). The patron Morgan supported Curtis and his project with a kind of bursary, which laid a cornerstone for the publication of his encyclopaedia, but which was insufficient to bring the whole project to a conclusion.

Thus the photographer was obliged to find other sources of income. He held lectures and published articles, as a result of which his photographs became better known and more saleable. In 1914 Curtis even shot a feature film, entitled *In the Land of the Headhunters*, based on the life of the Indians on the Pacific northwest coast. The fact that an Indian ethnic group was placed at the centre of the film and determined the entire plot made Curtis' work a first in film history.

It is only recently that Curtis has met with greater interest as an author and researcher of Indians. His contemporaries reacted in markedly different ways to his undertaking. Despite Roosevelt's political backing, the project found no state sponsorship. Established ethnologists and anthropologists regarded Curtis' activities with suspicion. The photographer had no academic training, and yet thanks to his contacts with people in high places and to his skills as a lecturer he was better known than many a professor. The scientists were above all offended by the aesthetic character of his photographs. Curtis wanted to present the fruits of his expeditions in artistic form, and indeed his pictures do betray an idealized view of reality. The photographer "staged-managed" his models in their surroundings, and was not content with the simple, matter-of-fact directions that documentary photographers normally give to their models.

Ethnologists and anthropologists at American universities wanted to see a strict division between art and science, as a result of which they punished the beautiful but extremely pricey limited edition of *The North American Indian*, as well as the popular magazines that printed Curtis' photos, by ignoring them. In all fairness, however, it should be added that Curtis for his part paid scant attention to other people's researches in this field, which rightly met with consternation.

Curtis has often been depicted as a lone wolf trying to accomplish the work of an entire institution. This image may well have had its origins in the way he presented himself in public. Yet the photographer by no means conducted his researches on his own, but rather apportioned the core areas of the work among a team of up to 17 collaborators. Some of these helpers accompanied him during

his researches in the field, while others worked in his Seattle photo studio, or assisted with production of the encyclopaedia, or sold books and photographs.

Public and scientific interest in the progress of Curtis' great work had already largely disappeared by the early 1920s. For the ageing photographer, who at 59 once more journeyed forth to the Arctic for the last volume, the task of finishing the 20th tome and 20th portfolio exerted such a heavy financial and mental strain that he was completely drained, both physically and emotionally. A Boston bookseller by the name of Charles Lauriat took over the none too successful distribution of the remaining volumes and gravures. In the years following completion of the project, Curtis worked on the manuscript of his late work, the book *The Lure of Gold*, which was never published. The photographer died in 1952 at the age of 84, at Whittier, California, not far from Los Angeles.

It is hard to do justice to such an extensive and qualitatively heterogeneous body of work as that left by Curtis. Are his Indian photographs documents? Are his pictures with their magical quality truly an echo of an age in which people still lived in harmony with nature?

Subscribing to a humanistic, social standpoint, Curtis attempted with passionate enthusiasm to record in words and pictures a culture that was, so he believed, threatened with immediate extinction. His portraits have given a lasting face to the indigenous peoples of the American continent. They are photographs that have imprinted themselves on our minds: shots of Indians who radiate strength and dignity, images that document a great cultural diversity, and pictures that express the universal values of the individual, the family, the tribe and the nation. In Curtis' encyclopaedia, the Indian tribes are at last united in peace and brotherhood. His photographs show the Indian heritage and make it a part of American history. Whatever reservations we may have about them – that they are posed, idealistic or romantic – nevertheless they also represent an American dream, a dream of pride and freedom.

Auf der Suche nach der verlorenen Zeit

Edward S. Curtis und
die Indianer Nordamerikas

Wenn wir in einem Buch, einer Zeitschrift oder auf einer Plakatwand ein altmodisch wirkendes Schwarzweißphoto sehen, das einen einsamen Indianer in den Weiten der Prärie, einen Häuptling mit Federschmuck oder eine Squaw vor einem Tipi zeigt, dann ist es nicht unwahrscheinlich, daß es sich um ein Bild von Edward Sheriff Curtis (1868–1952) handelt. Sein photographisches Werk kommt unserer traditionellen Vorstellung von den Indianern Nordamerikas nicht nur entgegen, es hat sie zu einem guten Teil geprägt. Curtis' Photographien zeigen Indianer wie sie einst gewesen sein mögen – oder vielleicht eher, wie wir sie uns gewünscht hätten.

Kein anderer Photograph hat ein größeres Œuvre zu diesem Thema geschaffen. Etwa seit der Wende zum 20. Jahrhundert verfolgte Curtis das Ziel, die bedrohten Traditionen der Indianerstämme in Wort und Bild festzuhalten. Über 30 Jahre lang studierte er ihr Leben und ihre Gebräuche und notierte ihre Geschichten und Legenden. Damit wurde der Photograph Curtis auch zum Ethnographen.

Das Ergebnis seiner langjährigen Arbeit mündete in der zwanzigbändigen Enzyklopädie The North American Indian, die umfangreiche Texte und rund 2200 Photogravüren umfaßte. Dieses Werk ist in nur kleiner Auflage zwischen 1907 und 1930 erschienen und kostete 3000 Dollar. Die Enzyklopädie deckt den gesamten amerikanischen Kontinent nördlich der mexikanischen Grenze und westlich des Mississippi ab und ist damit eine der wichtigsten historischen Publikationen über die Indianer. Sie gehört außerdem zu den schönsten Büchern der Welt, ledergebunden und mit Goldschnitt versehen, perfekt gedruckt auf schwerem Papier. Jeder der 20 in sich abgeschlossenen, mit jeweils ungefähr 75 Tafeln im Format von 14 x 19 cm sowie gelegentlich mit Graphiken und Karten illustrierten Textbände war einem oder einer Reihe von verwandten oder topographisch

benachbarten Indianerstämmen Nordamerikas gewidmet. Eine separate Bild-
mappe im Portfolioformat, die jeden einzelnen Band begleitete, enthielt in der
Regel 36 große Abbildungen im Format von ca. 30 x 40 cm. Diese Photogravüren
gelangten auch als Sonderdrucke in den Handel und besonders auf diesen hoch-
wertigen Drucken, deren Highlights wir in diesem Band vorstellen, beruht
Curtis' Ruf als Photograph. Den Höhepunkt seines Ruhmes dürfte er zwischen
1905 und 1914 erreicht haben. Bei Erscheinen des letzten Bandes seiner Enzy-
klopädie im Jahr 1930 war er nur noch wenigen Spezialisten vertraut.

Edward Sheriff Curtis stammte aus einfachen Verhältnissen. Er wurde 1868
auf einer Farm in Wisconsin geboren. Sein Vater, ein Bürgerkriegsinvalide, war
Wanderprediger und manchmal begleitete Edward Sheriff den Vater auf tage-
langen Ritten durch die Prärie und lernte so das Leben unter freiem Himmel
kennen. Edward ging nur sechs Jahre zur Schule. Er scheint sich schon früh auto-
didaktisch mit der Photographie befaßt zu haben und machte eine Lehre in
St. Paul, Minnesota. Nach dem frühen Tod des Vaters ließ sich die Familie in
Seattle im Staat Washington nieder, wo der junge Curtis nach einigen Anläufen
1897 ein bald expandierendes Photostudio eröffnen konnte. In seinem auf
Porträtphotographie spezialisierten Atelier ließen sich Berühmtheiten wie die
russische Tänzerin Anna Pawlowa (1881–1931) oder der Literatur-Nobelpreis-
träger Rabindranath Tagore (1861–1941) ablichten.

Bereits um 1890 hatte Curtis begonnen, in der Umgebung von Seattle
zu photographieren, z. B. die Indianer des nahen Puget Sound oder die Gebirgs-
landschaften des Mount Rainier. Diese Wildnis kannte er so gut, daß er dort
gelegentlich als Bergführer arbeitete. 1898 kam er in den Bergen zufällig einer
Gruppe von Wissenschaftlern, die sich verirrt hatte, zur Hilfe. Diese Begegnung
sollte sein Leben grundlegend verändern. Aus dem Kontakt ergab sich der hoch-
interessante Auftrag, im folgenden Jahr die private Alaska-Expedition des Eisen-
bahnmagnaten Edward Harriman als Photograph zu begleiten. Auf der Tour
lernte Curtis einige äußerst renommierte amerikanische Wissenschaftler ken-
nen und knüpfte engeren Kontakt zu dem Ethnographen und Indianerexperten
George Bird Grinnell (1849–1938). Bereits 1900 unternahmen die beiden
gemeinsam eine Expedition nach Montana, wo Curtis Gelegenheit hatte, unter
Indianern zu leben und sie zu photographieren. Die Anwesenheit beim Sonnen-
tanz der Blood-, Schwarzfuß- und Algonquin-Stämme wurde für den Photogra-
phen nach der Teilnahme an der Harriman-Expedition zum zweiten Schlüssel-
erlebnis.

Trotz seiner wachsenden Begeisterung für die Indianer wußte Curtis anfangs wenig über sie und teilte zunächst das Vorurteil der Weißen, ihre Religion sei ein bedeutungsloser Aberglaube ohne tieferen Sinn. Aber sein Wunsch, mehr über die einzelnen Stämme zu erfahren war geweckt. Für seine ersten Bilder bat er Indianer, berühmte Schlachten nachzustellen oder Zeremonien vorzuführen, wobei er versuchte, jegliche Zeichen der Anpassung der Indianer an die Kultur des weißen Mannes auszublenden. Seine indianischen Modelle, die meist in Reservaten lebten, posierten gerne für den Photographen, als wollten auch sie damit ihre Vergangenheit wieder einfangen, jenes scheinbar sorgenfreie alltägliche Leben und jene Spiritualität, die ihnen die Weißen genommen hatten.

Die Idee, eine umfangreiche Dokumentation über das traditionelle Leben der Indianerstämme Nordamerikas zu schaffen, entstand um 1903. Curtis faßte den Plan, die Geschichte aller Indianerstämme, ihr Leben, ihre Zeremonien und ihre tradierten Legenden und Mythen systematisch in Wort und Bild festzuhalten. Die Bereiche, die er untersuchen wollte, waren Sprache, soziale und politische Organisation, geographisches Umfeld, Wohnverhältnisse, Kleidung, Nahrungsmittelbeschaffung und -zubereitung, Maße und Gewichte, religiöse Bräuche sowie Sitten und Zeremonien bei Geburt, Ehe und Tod, ferner Spiele, Musik und Tänze.

Bis 1928 besuchte Curtis mehr als 80 Indianerstämme. Um seiner selbstgestellten Aufgabe gerecht zu werden, mußte er über viele Jahre bei Hitze und Kälte, in extremer Trockenheit und tiefem Schnee photographieren. Er widmete sich der schwierigen Überzeugungsarbeit, die Indianer für sein Vorhaben zu gewinnen.

Aufgrund seiner Neugierde und Unwissenheit übertrat Curtis anfangs ungewollt manch ungeschriebenes Gesetz und wurde von den Indianern entsprechend kühl aufgenommen. Obwohl er im Laufe der Zeit mehrere Indianersprachen erlernte, erschien es ihm – auch angesichts der frühen Mißgeschicke – vorteilhaft, ein Mitglied des Stammes als Berater und Vertrauten an seiner Seite zu haben. Mit der Zeit gewann Curtis das Vertrauen und die Freundschaft der Indianer, die ihn zunehmend als Chronisten ihrer Traditionen schätzten. Da die nordamerikanischen Indianerstämme keine schriftlichen Zeugnisse besaßen, beschäftigte sich Curtis intensiv mit ihrer mündlichen Überlieferung. Er zeichnete die Biographien der bedeutenden Häuptlinge, Krieger, Medizinmänner und Priester auf und mit Hilfe eines frühen Aufnahmegerätes hielt er die Musik der Indianer fest. Als sich Curtis' Forschungen ihrem Ende zuneigten, geschah es,

daß Stämme, die er seit Jahren vergeblich zu kontaktieren versucht hatte, ihn informierten, sein Besuch sei ihnen nun willkommen. Es war den Indianern bewußt geworden, daß Curtis und seine Mitarbeiter die einzigen waren, die ihre Traditionen in Wort und Bild dokumentieren wollten.

Obwohl Curtis' Indianerbilder bereits kurz nach der Jahrhundertwende sehr bekannt waren, vermochte der Photograph sein anspruchsvolles Dokumentationsprojekt mit dem Verkauf von Lichtbildern allein nicht zu finanzieren. Es erwies sich als glücklicher Umstand, daß Präsident Theodore Roosevelt Curtis' Arbeiten kennenlernte und einen Kontakt zu dem Finanzier John Pierpont Morgan (1837–1913) herstellte. Der Mäzen Morgan unterstützte Curtis mit einer Art Stipendium, das den Grundstein für die Publikation legte, aber nicht ausreichte das gesamte Projekt abzuschließen.

So war Curtis gezwungen, sich weitere Einnahmequellen zu verschaffen. Er hielt Vorträge und publizierte Artikel, wodurch wiederum seine Photographien bekannter wurden und besser verkauft werden konnten. 1914 drehte er unter dem Titel *Im Land der Kopfjäger* sogar einen Spielfilm über das Leben der Indianer an der pazifischen Nordwestküste. Die Tatsache, daß eine indianische Ethnie im Mittelpunkt des Filmes steht und das gesamte dramatische Geschehen bestimmt, machte dieses Werk zu einem filmgeschichtlichen Novum.

Als Autor und Indianerforscher findet Curtis erst in jüngerer Zeit stärkere Beachtung. Die Zeitgenossen reagierten sehr unterschiedlich auf sein Projekt. Trotz Roosevelts politischer Unterstützung wurde das Projekt staatlicherseits nicht gefördert. Den etablierten Ethnologen und Anthropologen war Curtis' Tätigkeit suspekt. Der Photograph konnte keine akademische Ausbildung vorweisen, war aber aufgrund seiner Kontakte zu hochgestellten Persönlichkeiten und dank seiner Vortragskünste bekannter als mancher Professor. Die Wissenschaftler nahmen vor allem Anstoß am Kunstcharakter seiner Photographien und tatsächlich zeugen die Bilder von einem idealistischen Blick auf die Wirklichkeit. Der Photograph setzte seine Modelle in ihrer Umgebung in Szene und beschränkte sich nicht auf die einfachen, sachlichen Regieanweisungen, die Dokumentarphotographen üblicherweise ihren Modellen geben.

Die Wissenschaftler an den amerikanischen Universitäten wollten Kunst und Wissenschaft streng getrennt sehen. Mit Nichtachtung straften sie daher die wunderschöne, jedoch extrem teure, limitierte Auflage des *North American Indian* sowie die populären Magazine, in denen Curtis' Photos erschienen. Aller-

dings interessierte sich Curtis auch kaum für die Forschungen anderer, was zu Recht auf Befremden stieß.

Oft ist Curtis als Einzelgänger dargestellt worden, der die Arbeit einer ganzen Institution zu leisten versuchte. Dieses Bild mag in der öffentlichen Selbstdarstellung des Photographen begründet liegen. Er führte seine Forschungen jedoch keinesfalls allein durch, sondern teilte die Arbeitsschwerpunkte innerhalb eines Teams von bis zu 17 Mitarbeitern auf. Einige seiner Leute begleiteten ihn während der Feldforschungen, andere arbeiteten im Photostudio, im Vertrieb oder bei der Buchproduktion mit.

Bereits Anfang der 1920 Jahre war ein öffentliches oder wissenschaftliches Interesse am Fortgang von Curtis' Werk kaum noch vorhanden. Für den alternden Photographen, der 59jährig für den letzten Band noch einmal in die Arktis reiste, war mit dem Abschluß des 20. Bandes und der 20. Mappe ein derartig starker finanzieller und psychischer Druck verbunden, daß er sich physisch und emotional völlig erschöpfte. Ein Bostoner Buchhändler namens Charles Lauriat übernahm den nicht sehr erfolgreichen Vertrieb der verbleibenden Bände und Gravüren. In den Folgejahren arbeitete Curtis am Manuskript seines nie veröffentlichten Alterswerks, *Der Lockruf des Goldes*. 1952 starb der Photograph 84jährig im kalifornischen Whittier in der Nähe von Los Angeles.

Es ist schwer, einem so umfangreichen und qualitativ heterogenen Werk wie dem von Curtis Gerechtigkeit widerfahren zu lassen. Sind seine Indianerphotographien Dokumente? Sind seine Bilder mit ihrer magischen Qualität wirklich das Echo einer Zeit, in der Mensch und Natur noch in Einklang standen? Leidenschaftlich hatte Curtis versucht, mit Notizblock und Kamera Zeugnisse einer Kultur festzuhalten, von der er glaubte, sie sei unmittelbar vom Untergang bedroht. Curtis folgte einem humanistisch-sozialen Denkansatz. Seine Porträts haben den Ureinwohnern des amerikanischen Kontinents ein bleibendes Gesicht gegeben. Es sind Lichtbilder, die sich unserem Gedächtnis eingeprägt haben: Bildnisse von Indianern, die Kraft und Würde ausstrahlen, Bilder, die eine große kulturelle Vielfalt dokumentieren und Bilder, die die universellen Werte von Individuum, Familie, Stamm' und Nation zum Ausdruck bringen. In der Enzyklopädie von Curtis sind die Indianerstämme endlich friedlich und brüderlich vereint. Die Photographen zeigen das Erbe der Indianer und machen sie zu einem Teil der amerikanischen Geschichte. Bei allen Einschränkungen stellen sie doch auch einen amerikanischen Traum dar – den von Stolz und Freiheit.

La quête d'une époque révolue

Edward S. Curtis et
les Indiens d'Amérique du Nord

Quand dans un livre, une revue ou sur des affiches, nous voyons une photo en noir et blanc, à l'air un peu vieillot, qui représente un Indien solitaire au milieu des vastes étendues de la Prairie, un chef coiffé d'une parure de plumes ou une squaw devant un tipi, il n'est pas impossible qu'il s'agisse d'une image d'Edward Sheriff Curtis (1868–1952). Non seulement son œuvre photographique a tout pour satisfaire notre vision traditionnelle des Indiens, mais elle l'a même en grande partie conditionnée. Les photographies de Curtis ne montrent pas les Indiens tels qu'ils sont, mais tels qu'ils étaient peut-être autrefois – ou plutôt tels que nous aurions aimé qu'ils soient.

Aucun autre photographe n'a consacré à ce sujet une œuvre d'une telle ampleur. A partir du tournant du siècle environ, Curtis a poursuivi pendant plus de 30 ans l'objectif de fixer par le texte et l'image les dernières traditions vivantes des tribus indiennes. Il a étudié leur vie et leurs coutumes et noté leur histoire et leurs légendes. En ce sens, Curtis photographe a également fait œuvre d'ethnographe.

Le résultat de ces longues années de travail fut l'encyclopédie en 20 volumes intitulée *The North American Indian*, qui comprenait des textes fort documentés et quelque 2200 photogravures. Cette œuvre, qui ne connut qu'un faible tirage, parut entre 1907 et 1930 et coûtait 3000 dollars. L'encyclopédie couvre l'ensemble du continent américain compris entre le nord de la frontière mexicaine et l'ouest du Mississippi, ce qui fait d'elle l'une des publications historiques majeures sur les Indiens. Avec sa reliure en cuir dorée sur tranche et la perfection de son impression sur beau papier, elle figure en outre parmi les plus beaux livres du monde. Chacun des 20 volumes, formant une unité en soi et illustré d'environ 75 planches de format 14 x 19 cm, ainsi que parfois de cartes et de schémas, était consacré à une ou plusieurs tribus indiennes d'Amérique du Nord unies par des

liens de parenté ou proches d'un point de vue topographique. Un portfolio qui contenait en règle générale 36 grandes gravures d'environ 30 x 40 cm, accompagnait chacun des volumes. Ces photogravures étaient également commercialisées sous forme de tirages à part, et c'est principalement l'excellente qualité de leur impression, dont nous présentons les beaux moments dans ce volume, qui valut à Curtis sa réputation de photographe. Curtis aurait atteint l'apogée de sa carrière entre 1905 et 1914. Lorsque parut en 1930 le dernier volume de son encyclopédie, il n'était plus guère connu que de quelques spécialistes.

Issu d'un milieu modeste, Edward Sheriff Curtis naquit en 1868 dans une ferme du Wisconsin. Son père, invalide de la guerre civile, était un prédicateur itinérant. Edward Sheriff, qui accompagnait parfois son père dans ses longs voyages à cheval à travers la Prairie, fit ainsi de bonne heure l'expérience de la vie en plein air. Edward ne fréquenta l'école que pendant six ans. Il semble s'être intéressé de bonne heure à la photographie, en autodidacte, avant de faire un apprentissage à St. Paul, dans le Minnesota. A la mort du père, qui survint prématurément, la famille alla s'installer à Seattle, dans l'Etat de Washington, où, après quelques essais, le jeune Curtis put ouvrir, en 1897, un studio photo qui devait prendre rapidement de l'expansion. Se firent photographier dans son atelier, qui s'était spécialisé dans le portrait, des célébrités comme la ballerine russe Anna Pavlova (1881–1931) ou le Prix Nobel de littérature Rabindranath Tagore (1861–1941).

Dès 1890 environ, Curtis avait commencé à photographier dans les environs de Seattle, comme par exemple les Indiens du Puget Sound ou les paysages montagneux du Mont Rainier. Il connaissait si bien ces étendues sauvages qu'il y travaillait de temps en temps comme guide de montagne. En 1898, il vint par hasard en aide à un groupe de scientifiques qui s'y étaient perdus. Cette rencontre devait changer sa vie de façon radicale. Les contacts qu'il avait noués à cette occasion lui valurent, l'année suivante, la mission extrêmement intéressante d'accompagner, en tant que photographe, l'expédition privée du magnat des chemins de fer Edward Harriman en Alaska. Il rencontra à cette occasion quelques chercheurs américains de renom et noua plus étroitement connaissance avec l'ethnographe spécialiste des Indiens George Bird Grinnell (1849–1938). Les deux hommes entreprirent dès 1900 une expédition dans le Montana où Curtis eut l'occasion de vivre parmi des Indiens et de les photographier. La présence, pendant la Danse du Soleil, de tribus Blood, Blackfoot et Algonquin représenta pour Curtis, après sa participation à l'expédition Harriman, une seconde expérience clé.

Malgré sa fascination croissante pour les Indiens, Curtis à ses débuts ne savait que peu de choses d'eux, et il partageait le préjugé des Blancs qui voyaient dans leur religion de la simple superstition. Mais son désir d'en savoir plus sur les différentes tribus était éveillé. Pour ses premières images, il demanda à des Indiens de refaire les réglages de batailles célèbres ou de figurer des cérémonies, et s'efforça de faire disparaître tout signe qui aurait pu témoigner de l'adaptation des Indiens à la culture de l'homme blanc. Ses modèles indiens, qui vivaient le plus souvent dans des réserves, posaient volontiers, comme s'ils voulaient eux aussi se réapproprier leur passé, cette existence quotidienne apparemment insouciante et cette vie spirituelle que les Blancs leur avaient prises.

L'idée de créer une vaste documentation sur la vie traditionnelle des tribus indiennes d'Amérique du Nord date d'environ 1903. Le projet de Curtis consistait à fixer systématiquement par le texte et l'image l'histoire de toutes les tribus indiennes, leur vie, leurs cérémonies, leurs légendes et leurs mythes. Les domaines qu'il voulait interroger étaient la langue, l'organisation sociale et politique, le milieu géographique, l'habitat, les vêtements, l'approvisionnement et la préparation de la nourriture, les traditions religieuses ainsi que les us et coutumes relatifs à la naissance, au mariage et à la mort, auxquels s'ajoutaient les jeux, la musique et les danses.

Jusqu'en 1928, Curtis rendit visite à plus de 80 tribus différentes. Afin de satisfaire à la tâche qu'il s'était lui-même fixée, il dut pendant de nombreuses années photographier sous la chaleur et dans le froid, dans la sécheresse et sous la neige. Il lui fallut également déployer des trésors de persuasion pour gagner les Indiens à son projet.

Durant ses expéditions, la curiosité et l'ignorance de Curtis lui firent involontairement transgresser des lois coutumières, ce qui lui valut au début un accueil froid de la part des Indiens. Même si Curtis, au fil du temps, apprit les langues de plusieurs tribus, il lui semblait judicieux, ne serait-ce que par rapport aux mésaventures de ses débuts, d'avoir à ses côtés un membre de la tribu qui fasse office de conseiller et de confident. Avec le temps, Curtis gagna la confiance et l'estime des Indiens qui le considéraient de plus en plus comme le chroniqueur de leurs traditions. Les tribus indiennes d'Amérique du Nord ne possédant pas de documents écrits, Curtis s'intéressa tout particulièrement à leurs traditions orales. Il mit par écrit les biographies des chefs, des guerriers, des sorciers et des prêtres importants, et grâce à l'un des premiers appareils d'enregistrement, il put fixer leur musique. Lorsque les recherches de Curtis approchèrent de leur terme, il

arriva que des tribus qu'il avait en vain essayé de contacter depuis des années, lui firent savoir que sa visite serait à présent la bienvenue. Les Indiens avaient pris conscience du fait que Curtis et ses collaborateurs étaient les seuls à vouloir documenter leurs traditions par le texte et l'image.

Même si, peu de temps après le tournant du siècle, ses photos d'Indiens étaient déjà très connues, Curtis n'était pas en mesure de financer lui-même son ambitieux projet documentaire par la vente de ses clichés. Aussi la découverte de ses travaux par le président Theodore Roosevelt fut-elle une circonstance on ne peut plus heureuse, d'autant que ce dernier mit Curtis en contact avec le financier John Pierpont Morgan (1837–1913). En tant que mécène, Morgan apporta son soutien à Curtis sous la forme d'une sorte de bourse qui, si elle posa la première pierre de la publication, ne suffit pas à faire aboutir l'ensemble du projet.

Aussi Curtis se vit-il contraint à rechercher d'autres sources de revenus. Il fit des conférences et publia des articles, ce qui par ailleurs lui permit de mieux faire connaître ses photos et de mieux les vendre. Il alla même jusqu'à tourner, en 1914, un film de fiction sur la vie des Indiens de la côte Nord-Ouest du Pacifique, et intitulé *Au pays des chasseurs de têtes*. Le fait qu'une ethnie indienne soit au centre du film et conditionne toute l'intrigue faisait de l'œuvre de Curtis quelque chose de tout à fait nouveau dans l'histoire du cinéma.

Ce n'est qu'à une date récente qu'on commença à découvrir l'importance de Curtis en tant qu'auteur et historien ayant étudié les différentes tribus indiennes. Son projet rencontra des réactions très diverses de la part des contemporains. Malgré le soutien politique de Roosevelt, il n'eut aucun subside de la part de l'Etat. L'activité de Curtis était suspecte aux ethnologues et anthropologues établis. Le photographe en effet ne pouvait justifier d'aucune formation universitaire, mais grâce à ses contacts avec des personnalités haut placées et ses talents de conférencier, il était plus connu que bien des professeurs. Les scientifiques prirent essentiellement ombrage du caractère artistique de ses photographies, et il est de fait que la réalité qu'il montre dans ses images est une réalité idéalisée. Le photographe, qui mettait en scène ses modèles dans leur environnement, ne se limitait pas dans ses directives à de simples et sobres indications, comme il est d'usage en photographie documentaire.

Les chercheurs des universités américaines voulaient voir une franche séparation entre l'art et la science. C'est la raison pour laquelle ils sanctionnèrent de leur indifférence l'édition, superbe mais extrêmement coûteuse du fait de son tirage limité, des *North American Indian*, ainsi que les magazines populaires dans

lesquels paraissaient les photos de Curtis. Il faut toutefois reconnaître qu'en contrepartie, Curtis s'intéressait à peine aux recherches des autres, ce qui à raison provoqua des manifestations d'inimitié.

On a souvent représenté Curtis comme un individu qui essayait de faire à lui seul le travail de toute une institution. Cette image trouve peut-être son origine dans la façon qu'avait Curtis de paraître en public. Il n'effectuait pas pour autant ses recherches tout seul, mais répartissait les principales tâches au sein d'une petite équipe de 17 collaborateurs. Certains d'entre eux l'accompagnaient dans ses recherches sur le terrain, tandis que d'autres travaillaient dans le studio photo ou s'occupaient de la production de l'ouvrage.

Dès le début des années 1920, l'intérêt tant public que scientifique pour la poursuite de l'œuvre de Curtis avait toutefois presque disparu. La clôture du projet représentait pour le photographe vieillissant, lequel entreprit pour le dernier volume un nouveau voyage dans l'Arctique à l'âge de 59 ans, une pression financière et psychique telle qu'il s'épuisa entièrement. Un libraire de Boston du nom de Charles Lauriat prit en charge la commercialisation, qui s'avéra peu couronnée de succès, des volumes et des gravures restants. Dans les années qui suivirent, Curtis travailla plusieurs années au manuscrit de son œuvre de vieillesse, intitulé *L'appel de l'or*, qui ne fut jamais publié. Le photographe mourut en Californie à l'âge de 84 ans à Whittier, près de Los Angeles.

Il est très difficile de rendre justice à une œuvre aussi vaste et pourvue de qualités aussi diverses que celle de Curtis. Ses photographies d'Indiens sont-elles des documents ? La magie qui émane de ses images est-elle vraiment l'écho d'une époque où l'homme et la nature vivaient encore en harmonie ? Curtis a tenté avec passion de fixer par le carnet de notes et l'appareil photo les témoignages d'une culture qu'il croyait menacée de disparition. Le travail de Curtis avait des prémisses d'ordre social et humaniste. Ses portraits ont donné un visage impérissable à ces premiers habitants du continent américain. Ce sont des photographies qui se sont gravées dans nos mémoires, des portraits d'Indiens qui dégagent une impression de force et de dignité, des images qui illustrent une grande diversité culturelle, des images enfin qui expriment les valeurs universelles de la famille, de la tribu et de la nation. Dans l'encyclopédie de Curtis, les tribus indiennes sont enfin unies dans la paix et la fraternité. Ces photographies montrent l'héritage des Indiens, dont elles font une partie de l'histoire de l'Amérique. Quelles que soient les réserves qu'on puisse leur opposer, elles représentent, elles aussi, un rêve américain, un rêve de fierté et de liberté.

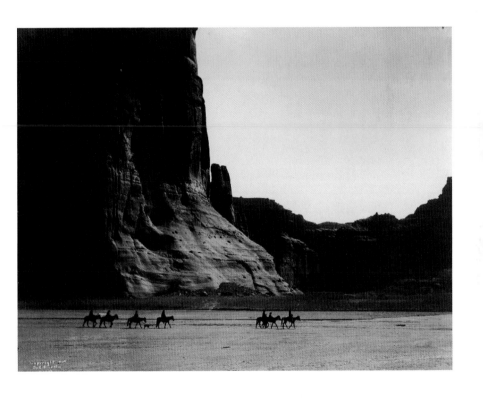

CAÑON DE CHELLY, 1904

THE VANISHING RACE
A Picture by Edward S. Curtis

Into the shadows, whose illumined crest
 Speaks of the world behind them where the sun
 Still shines for us whose day is not yet done,
Those last dark ones go drifting. East or West,
Or North or South – it matters not; their quest
 Is toward the shadows whence it was begun;
 Hope in it, Ah, my brothers! there is none;
And yet – they only seek a place to rest.

So mutely, uncomplainingly, they go!
 How shall it be with us when they are gone,
 When they are but a mem'ry and a name?
May not those mournful eyes to phantoms grow –
 When, wronged and lonely, they have drifted on
 Into the voiceless shadow whence they came?

ELLA HIGGINSON
(1860s–1940)

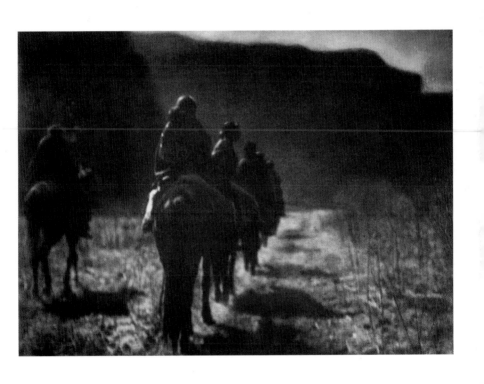

THE VANISHING RACE · NAVAHO, 1904
Die aussterbende Rasse | Une race qui s'éteint

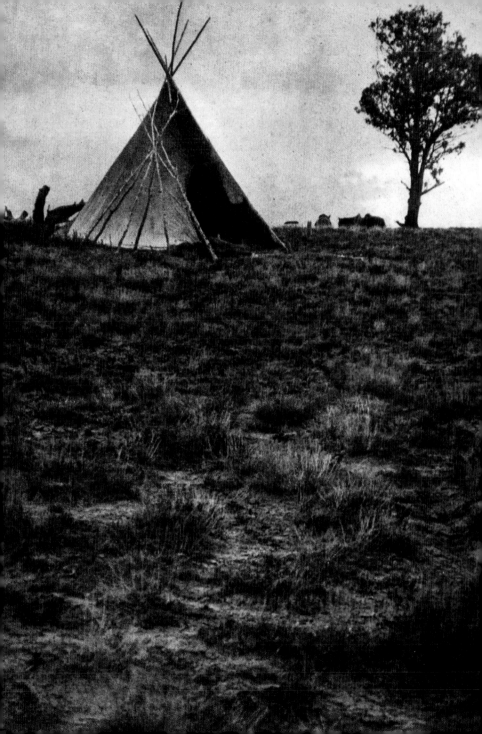

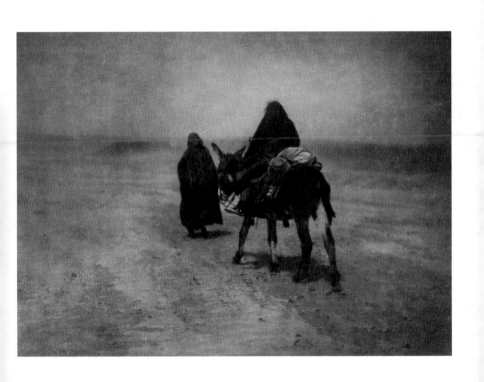

INTO THE DESERT · NAVAHO, 1904
Hinaus in die Wüste | Dans le désert

LONE TREE LODGE · JICARILLA, 1904

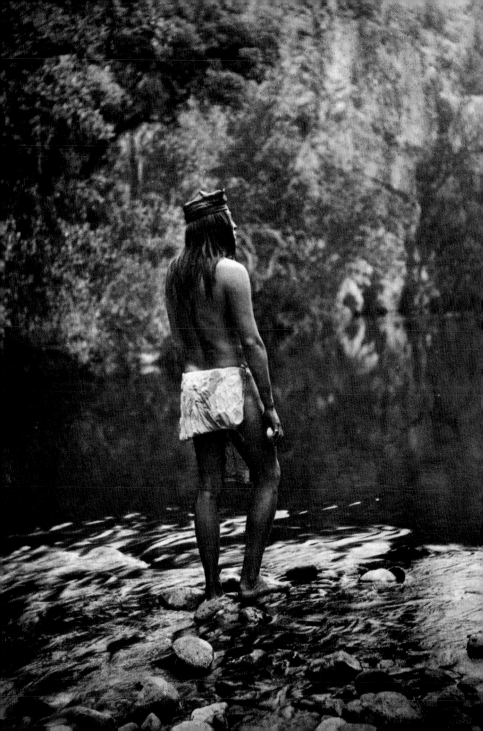

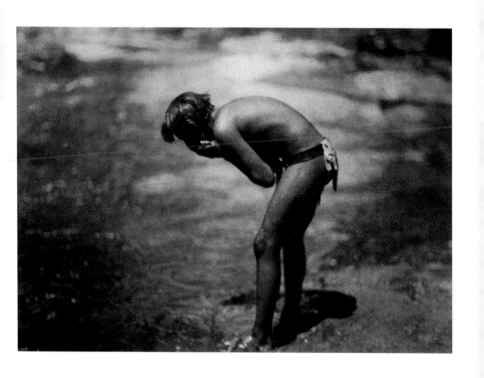

THE MORNING BATH · APACHE, 1906
Das morgendliche Bad | Le bain du matin

THE APACHE, 1906
Der Apache | L'Apache

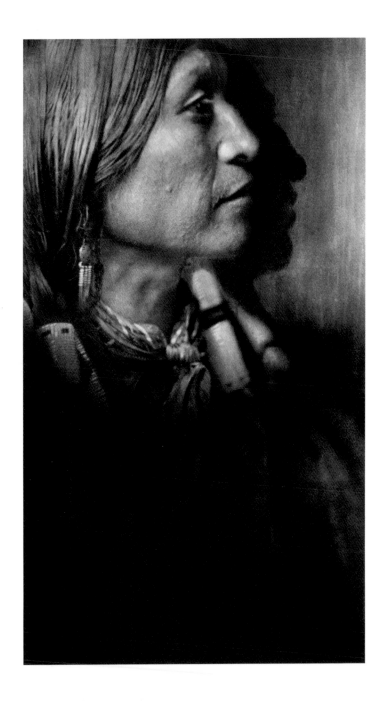

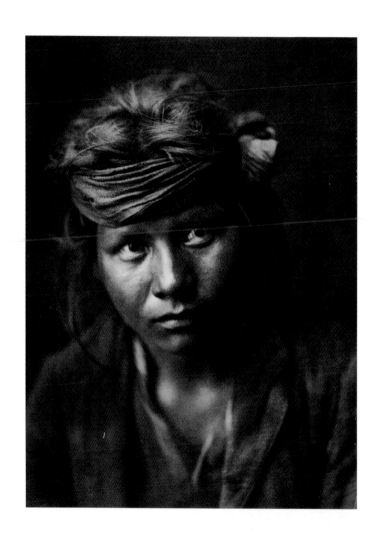

A SON OF THE DESERT · NAVAHO, 1904
Ein Sohn der Wüste | Un fils du désert

VASH GON · JICARILLA, 1904

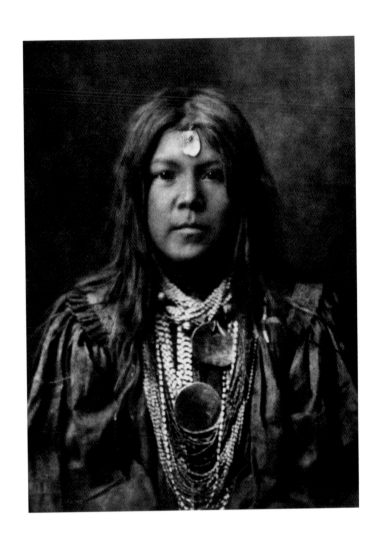

APACHE NALIN, 1903

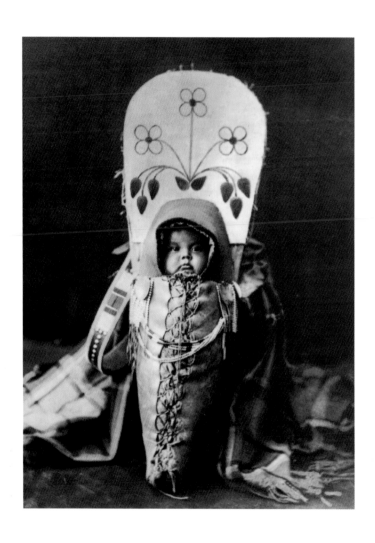

NEZ PERCÉ BABY, 1900
Säugling bei den Nez Percé | Bébé Nez Percé

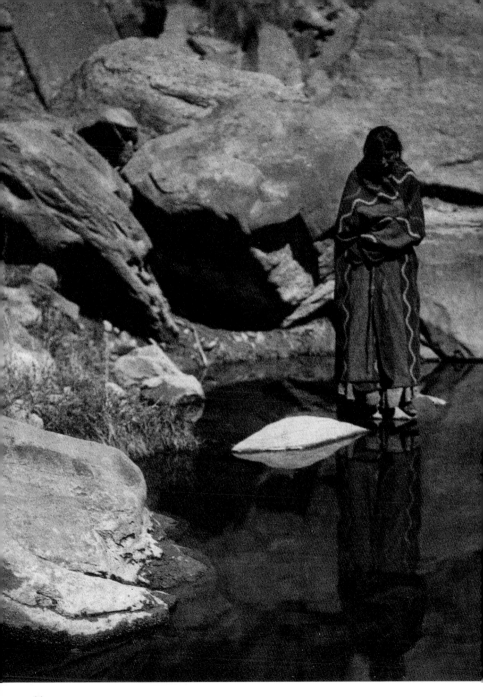

NATURE'S MIRROR
NAVAHO, 1904
Ein natürlicher Spiegel
Le miroir de la nature

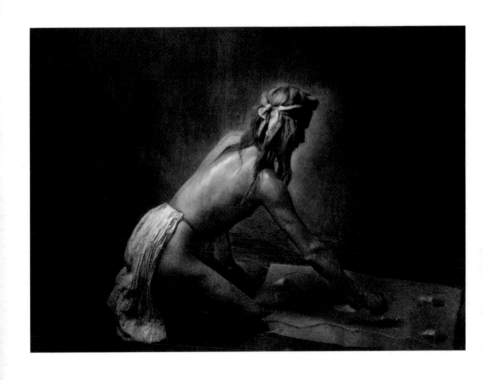

APACHE MEDICINE-MAN, 1907
Apache-Medizinmann | Sorcier apache

THE MEDICINE-MAN (SLOW BULL), 1907
Der Medizinmann (Slow Bull) | Le Sorcier (Slow Bull)

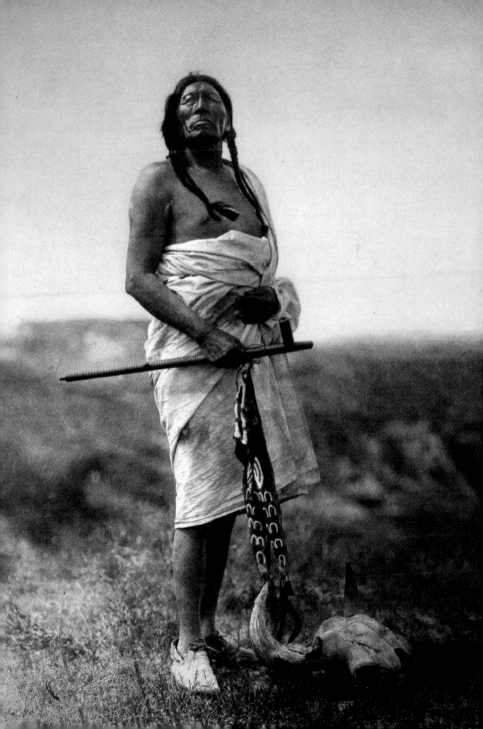

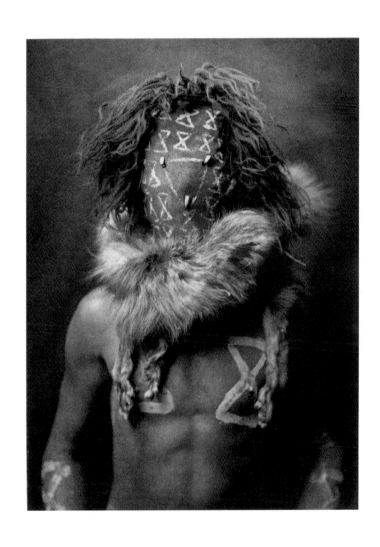

TOBADZISCHÍNI · NAVAHO, 1904

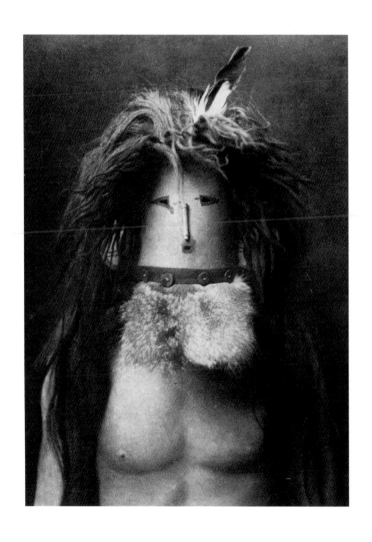

HASCHEBAÁD · NAVAHO, 1904

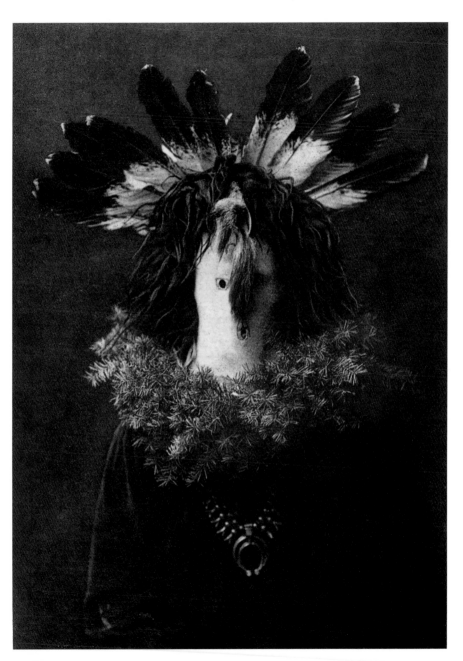

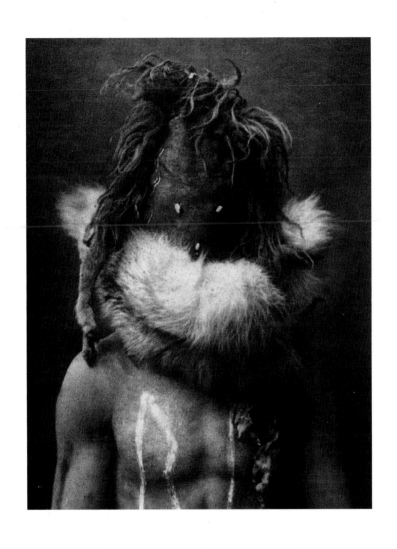

HASCHEZHINI · NAVAHO, 1904

HASCHÓGAN · NAVAHO, 1904

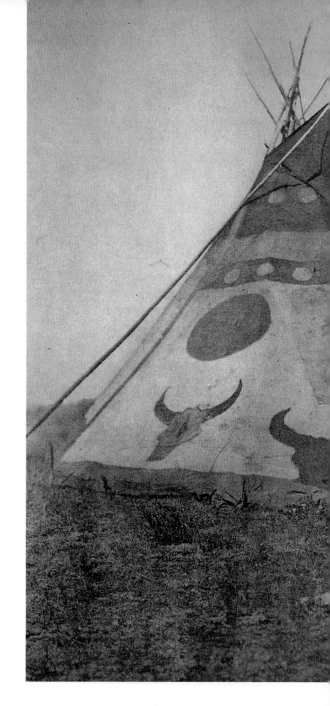

A PAINTED TIPI
ASSINIBOIN, 1926
Bemaltes Tipi
Un tipi peint

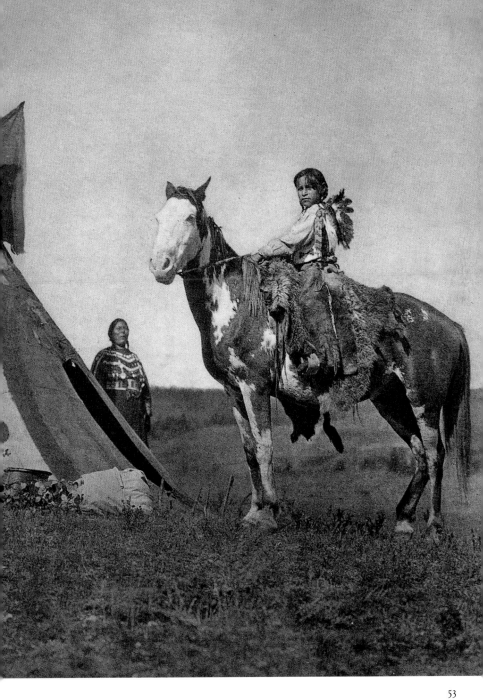

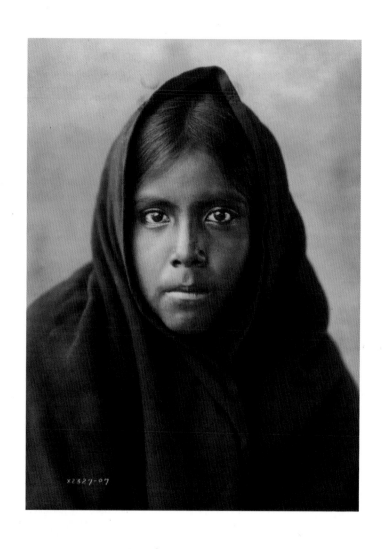

QAHÁTIKA GIRL, 1907
Qahátikamädchen | Jeune fille Qahátika

MÓSA · MOHAVE, 1903

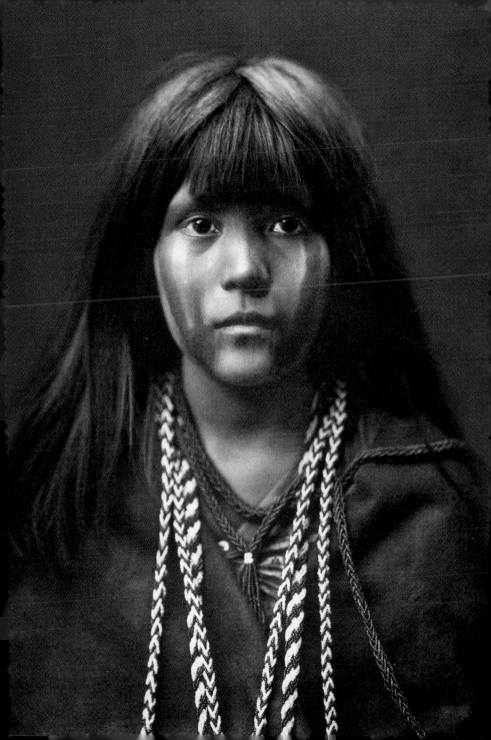

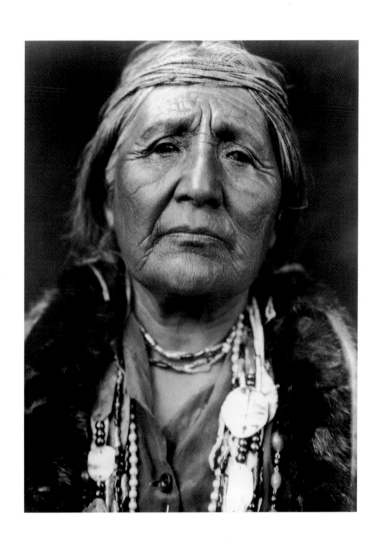

HUPA WOMAN, 1923
Hupafrau | Femme Hupa

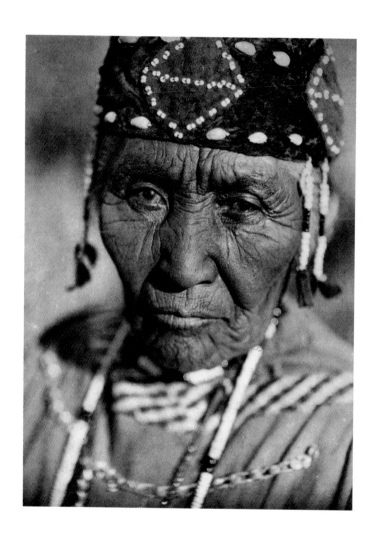

WIFE OF MODOC HENRY · KLAMATH, 1923
Modoc Henrys Frau | Femme de Modoc Henry

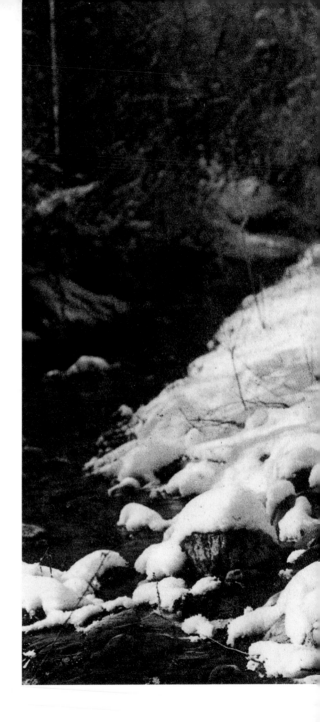

A WINTER DAY
APSAROKE, 1908
Ein Wintertag
Journée d'hiver

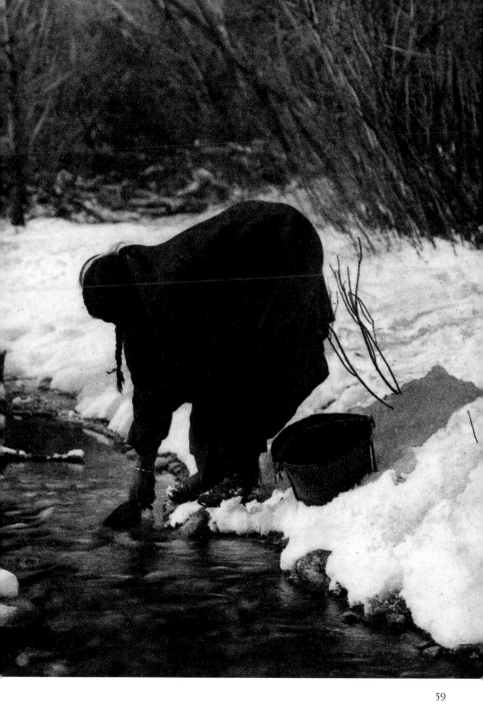

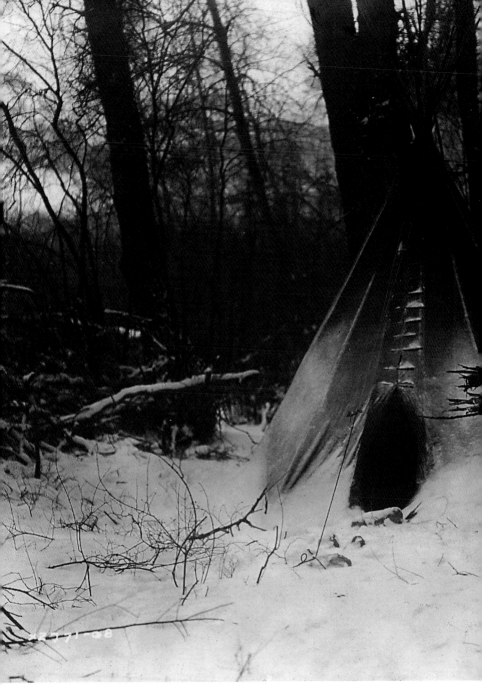

WINTER
APSAROKE, 1908
Winter | Hiver

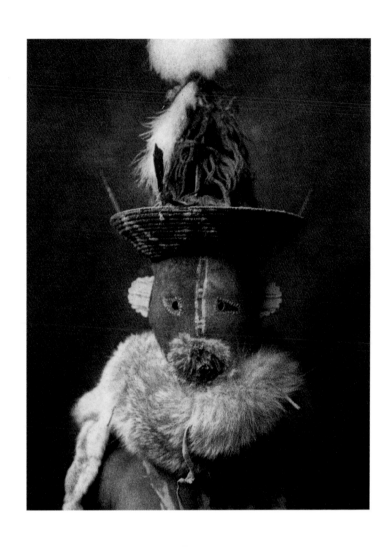

ZAHADOLZHÁ · NAVAHO, 1904

GÁNASKIDI · NAVAHO, 1904

AMERICAN HORSE · OGLALA (TETON SIOUX), 1908

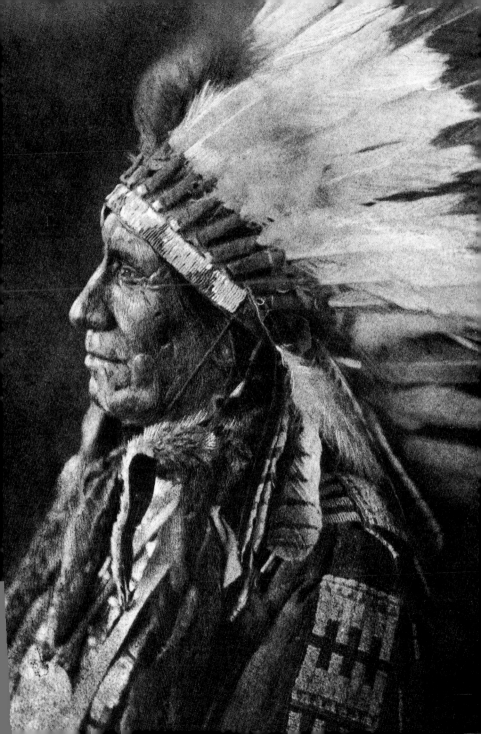

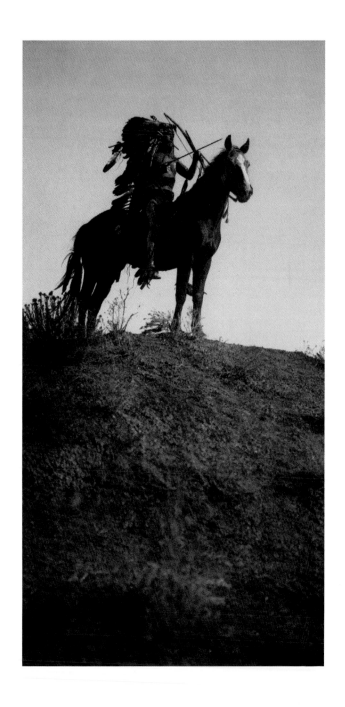

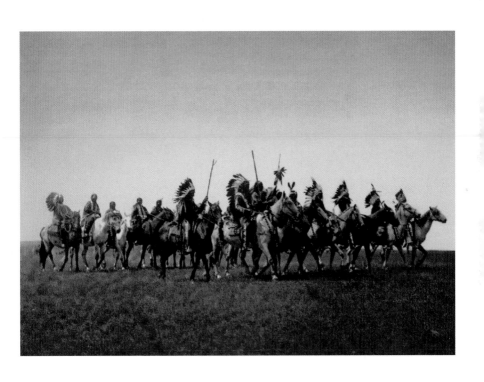

BRULÉ SIOUX WAR PARTY, 1907
Kriegergruppe der Brulé | Bande de guerriers brulés

READY FOR THE CHARGE · APSAROKE, 1908
Bereit zum Angriff | Prêt à charger

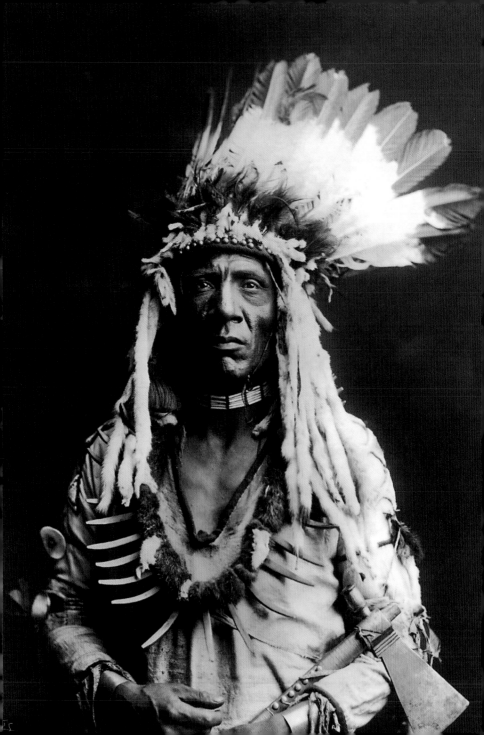

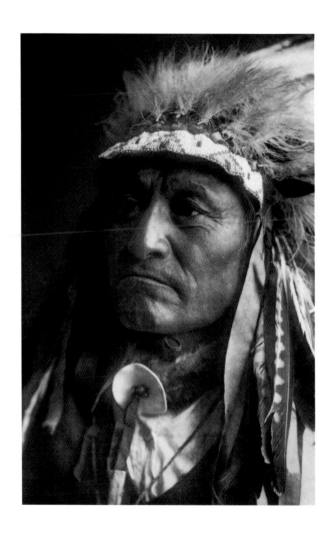

CRAZY THUNDER · OGLALA (TETON SIOUX), 1907

WEASEL TAIL · PIEGAN, 1900

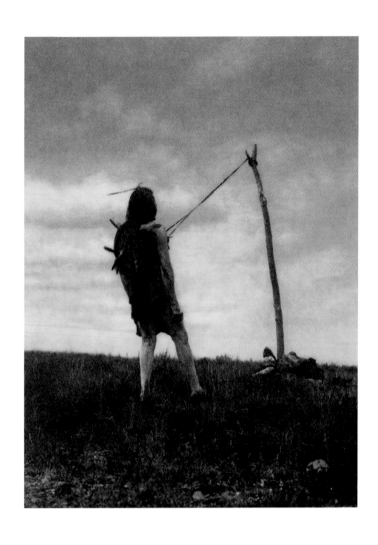

FOR STRENGTH AND VISIONS · APSAROKE, 1908
Um Kraft und Visionen zu erlangen | Pour la force et les visions

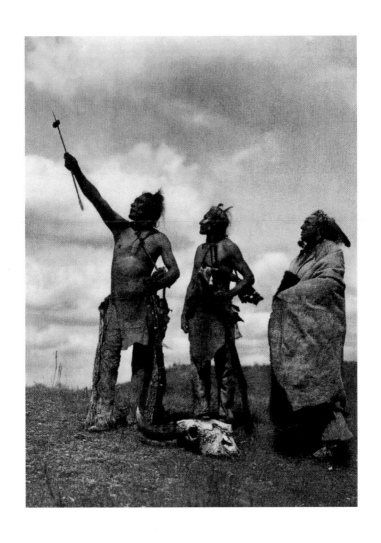

THE OATH · APSAROKE, 1908
Der Eid | Le serment

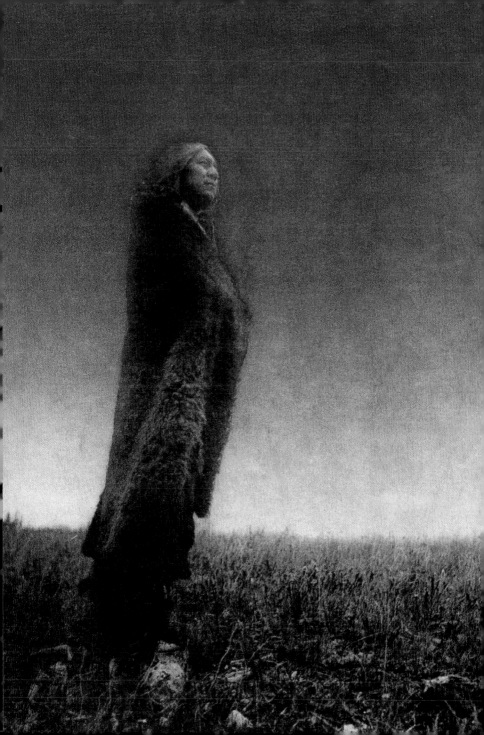

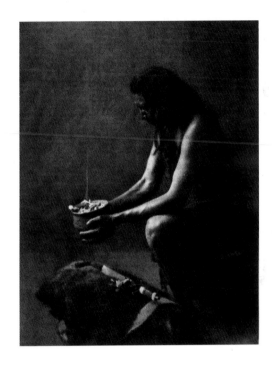

INCENSE OVER A MEDICINE BUNDLE · HIDATSA, 1908
Weihrauch über einem Medizinbündel | Encens au-dessus d'une préparation médicinale

CRYING TO THE SPIRITS, 1908
Die Geister werden angerufen | Invocation des esprits

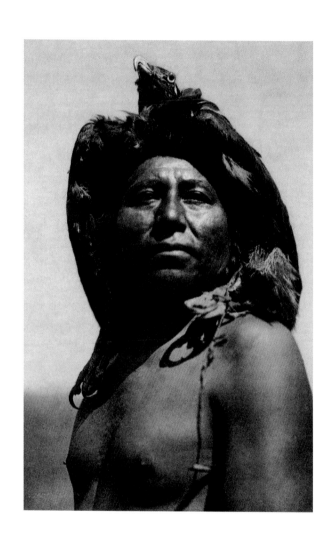

THE EAGLE MEDICINE-MAN · APSAROKE, 1908
Der Adler-Medizinmann | Le Sorcier aigle

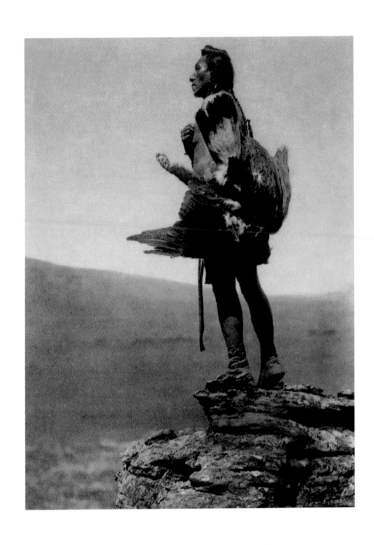

THE EAGLE-CATCHER, 1908
Der Adlerfänger | Le chasseur d'aigle

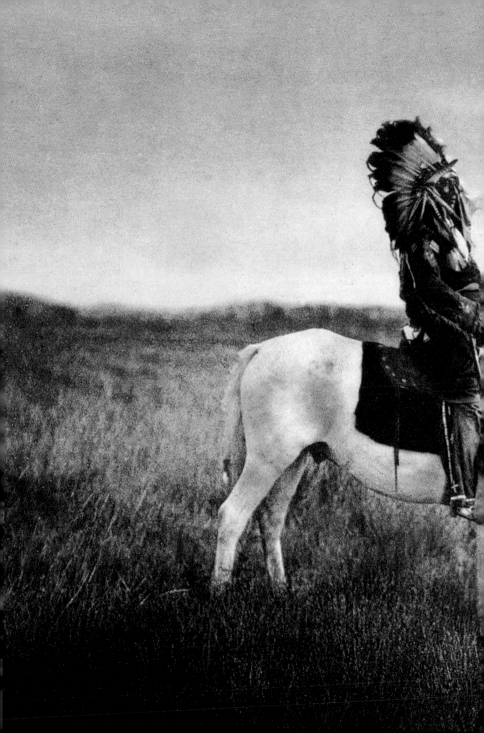

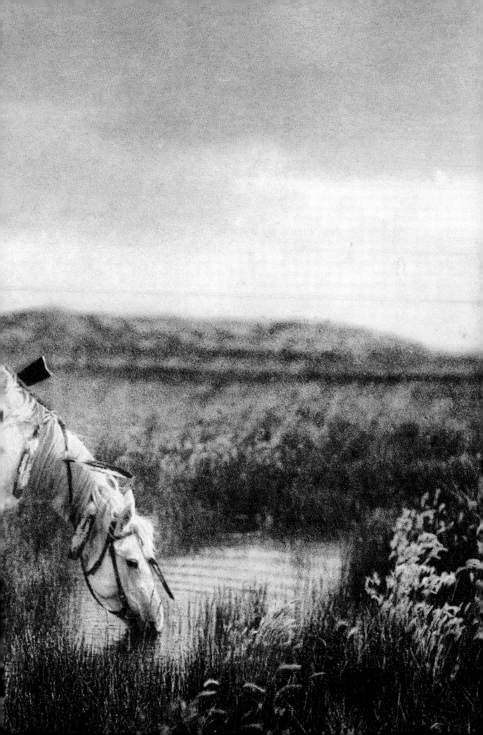

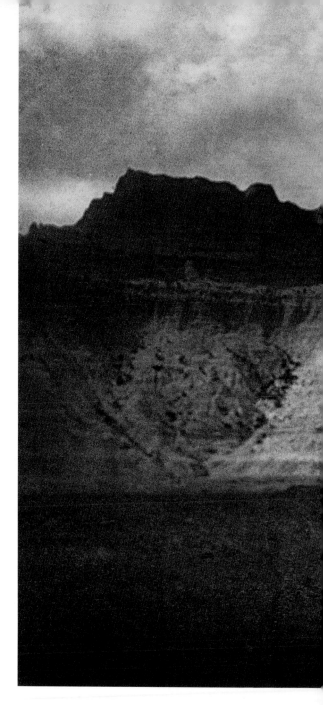

Pages | Seiten 76–77
AN OASIS IN THE BAD
LANDS, SOUTH
DAKOTA, 1905
Eine Oase in den Badlands,
Süddakota
Une oasis dans les Bad
Lands, Dakota du Sud

IN THE BAD LANDS,
SOUTH DAKOTA, 1904
In den Badlands, Süddakota
Dans les Bad Lands,
Dakota du Sud

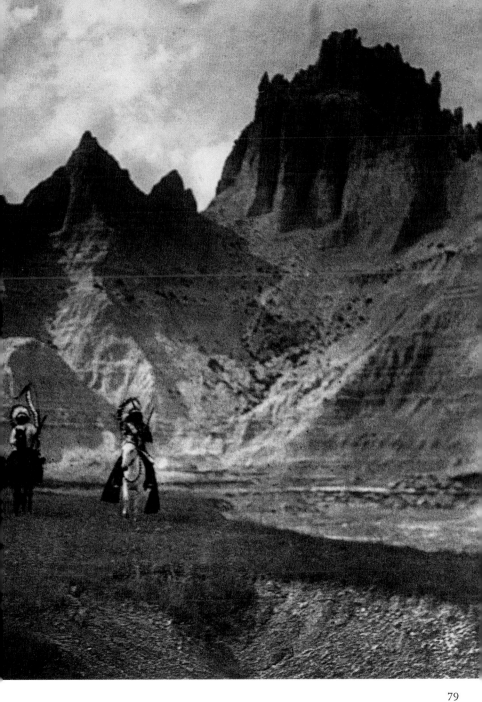

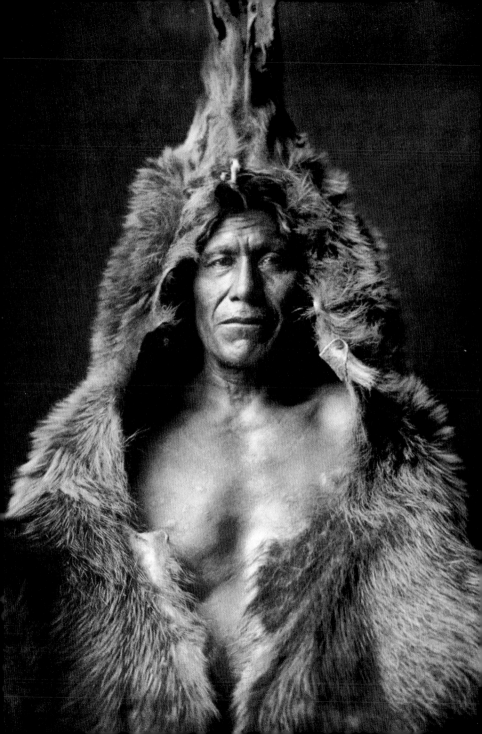

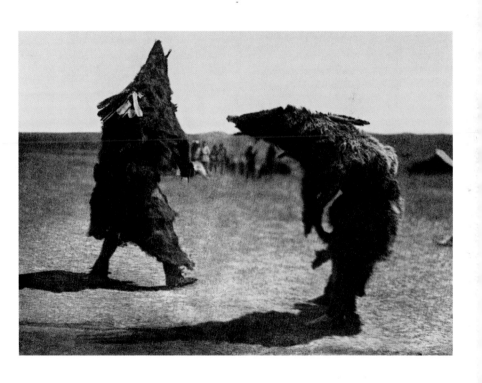

ARIKARA MEDICINE CEREMONY · THE BEARS, 1908
Ritual der Bruderschaft der Medizinmänner · Die Bären
Cérémonie de médecine Arikara · Les Ours

BEAR'S BELLY · ARIKARA, 1908

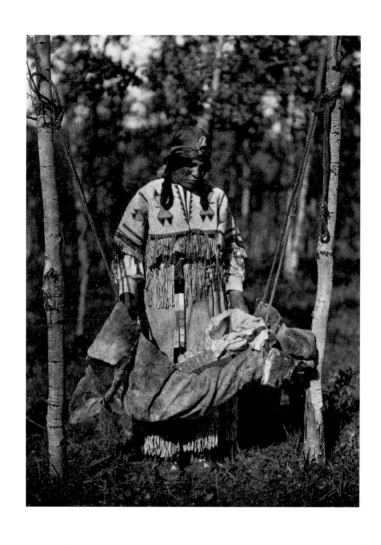

WOMAN'S COSTUME AND BABY SWING · ASSINIBOIN, 1926
Eine Frau im traditionellen Gewand und eine Babyschaukel
Costume de femme et balançoire d'enfant

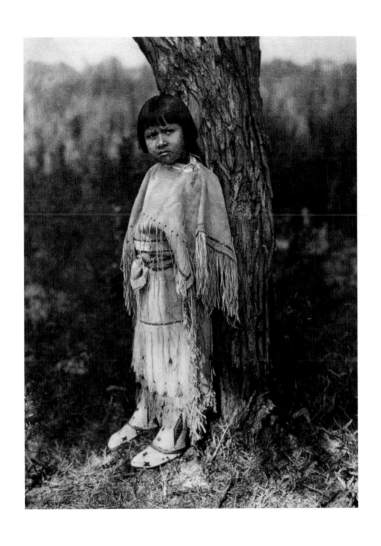

CHEYENNE CHILD, 1927
Kind der Cheyenne | Enfant Cheyenne

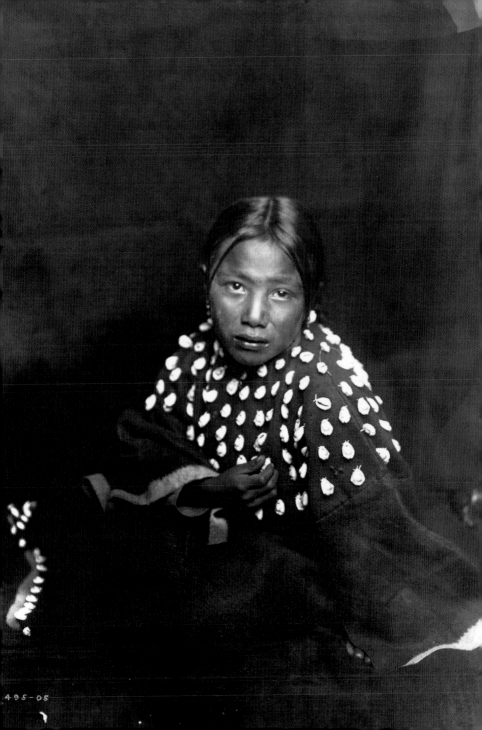

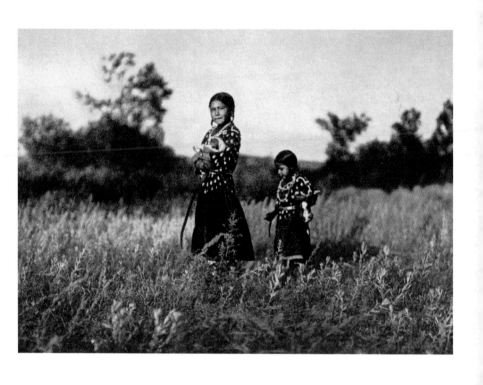

PLAYMATES · APSAROKE, 1905
Spielgefährten | Camarades de jeu

APSAROKE GIRL, 1905
Apsarokemädchen | Jeune fille Apsaroke

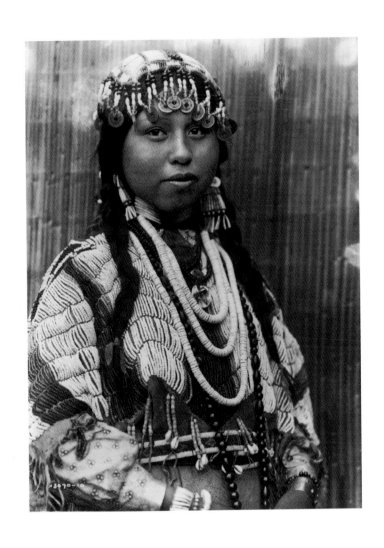

WISHRAM BRIDE, 1910
Braut bei den Wishram | Mariée Wishram

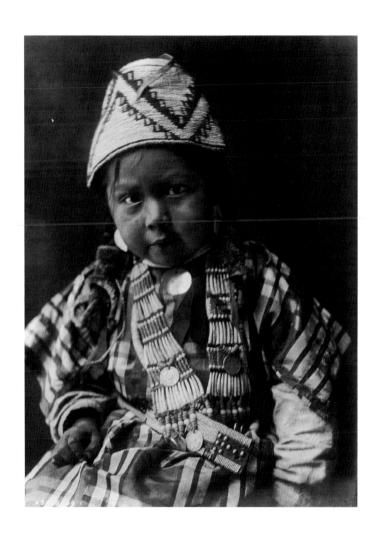

WISHRAM CHILD, 1909
Kind der Wishram | Enfant Wishram

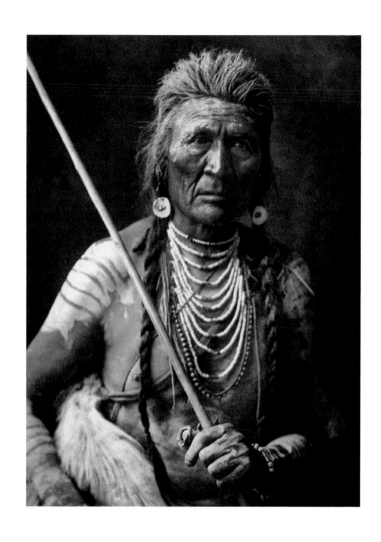

WOLF · APSAROKE, 1908

A TYPICAL NEZ PERCÉ, 1910
Ein typischer Vertreter der Nez Percé | Un Nez Percé typique

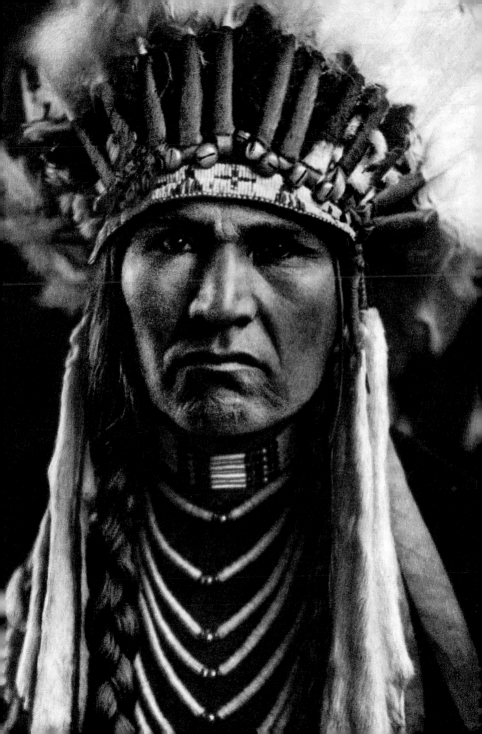

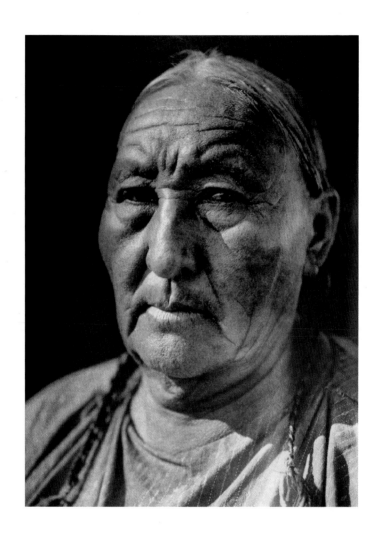

WOISTA · CHEYENNE WOMAN, 1927
Cheyennefrau | Femme Cheyenne

BULL CHIEF · APSAROKE, 1908

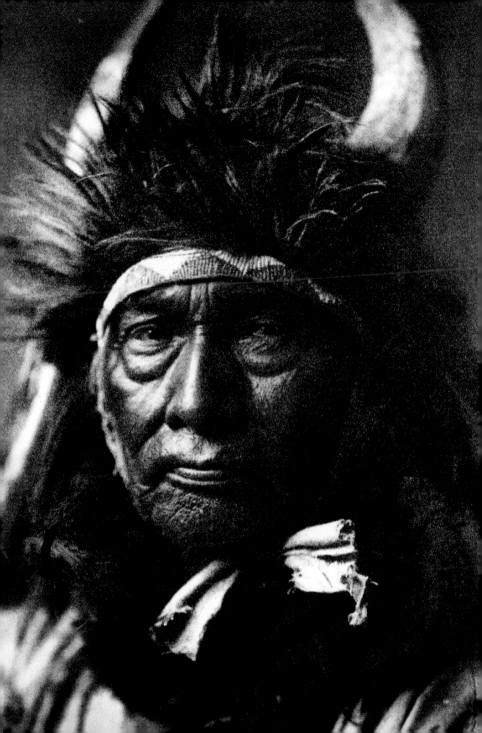

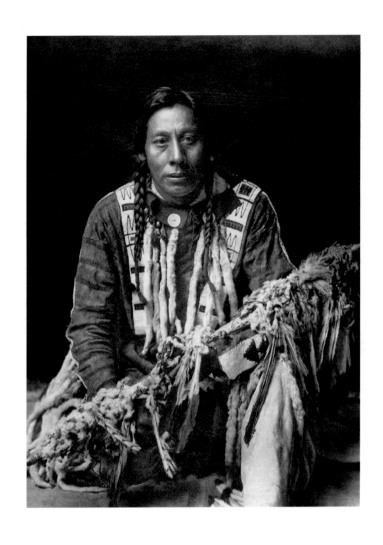

A MEDICINE-PIPE · PIEGAN, 1910
Eine Medizinpfeife | Une pipe à usage médicinal

SHOT IN THE HAND · APSAROKE, 1908

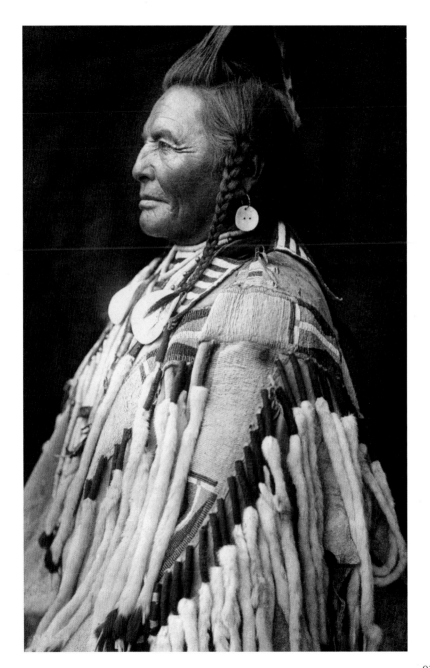

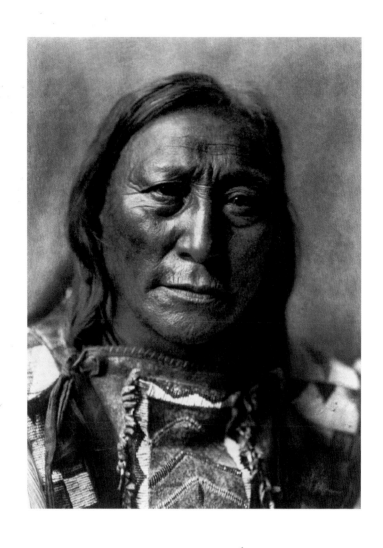

HOLLOW HORN BEAR · BRULÉ SIOUX, 1907

NEW CHEST · PIEGAN, 1910

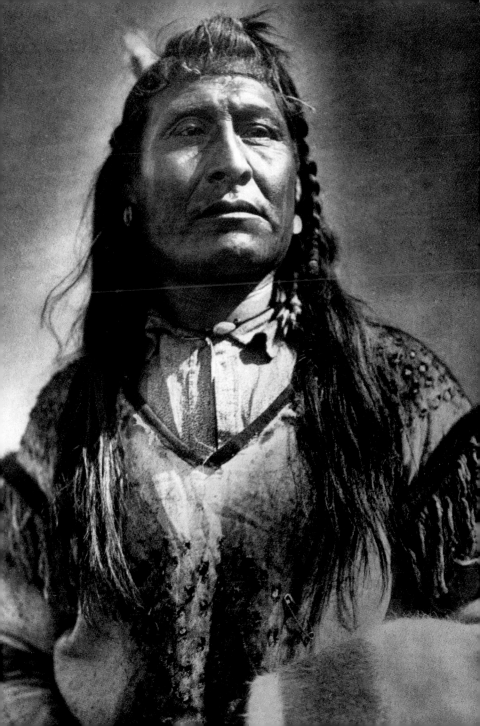

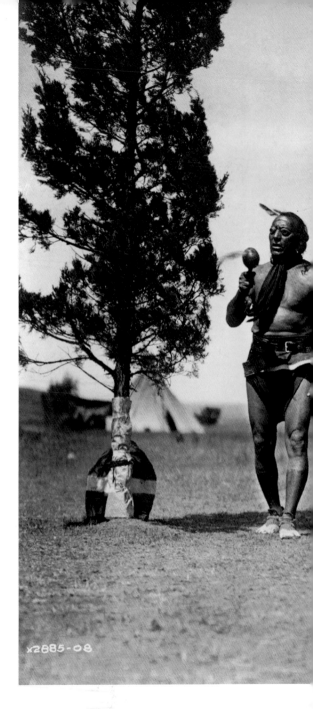

ARIKARA MEDICINE
CEREMONY · NIGHT
MEN DANCING, 1908
Medizinzeremonie der
Arikara · die Bruderschaft
der Männer der Nacht
beim Tanz | Cérémonie de
médecine Arikara · Danse
des hommes de la Nuit

x2885-08

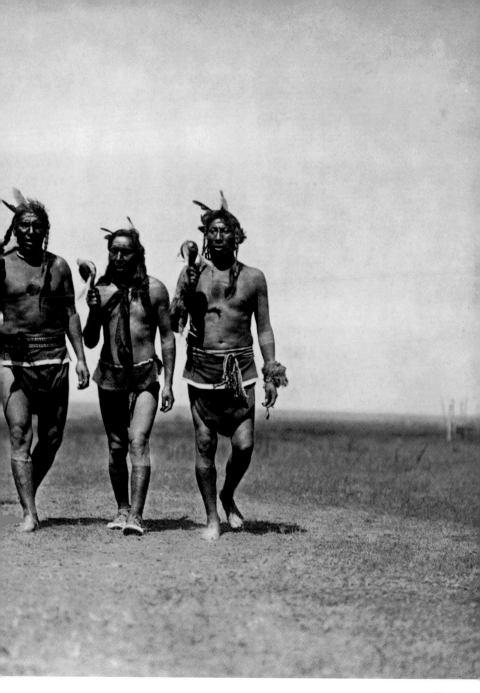

97

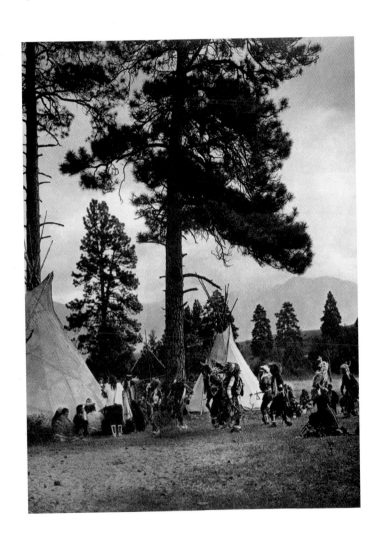

A FLATHEAD DANCE, 1910
Ein Tanz der Flathead | Danse Flathead

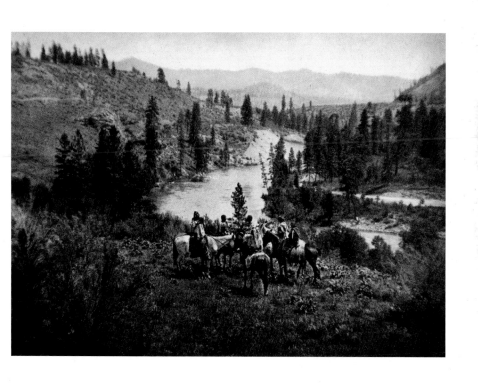

ON SPOKANE RIVER, 1910

Am Spokane-Fluß | Sur la rivière Spokane

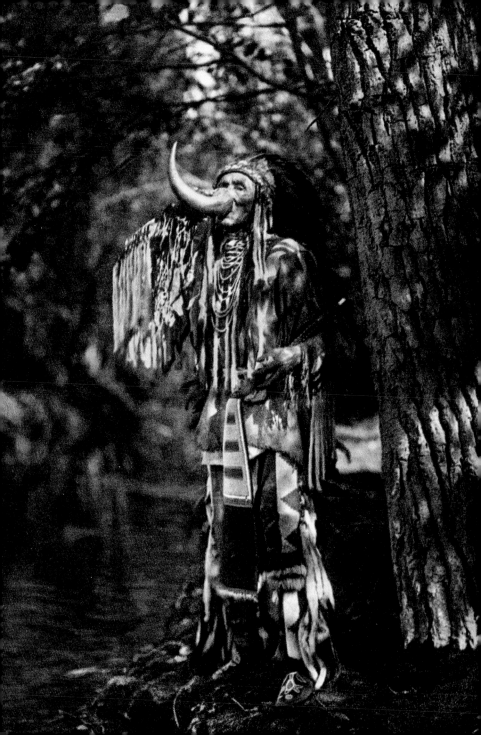

Pages | Seiten 102–103
THE CHIEF · KLAMATH, 1923
Der Häuptling | Le Chef

FLATHEAD WARRIOR, 1910
Krieger der Flathead | Guerrier Flathead

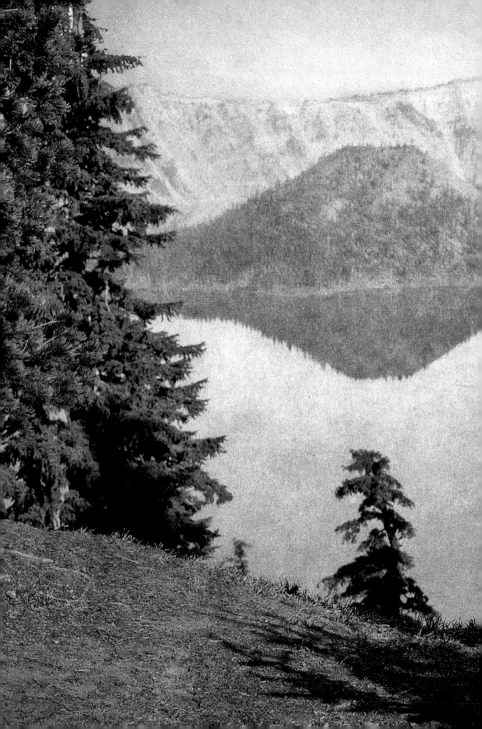

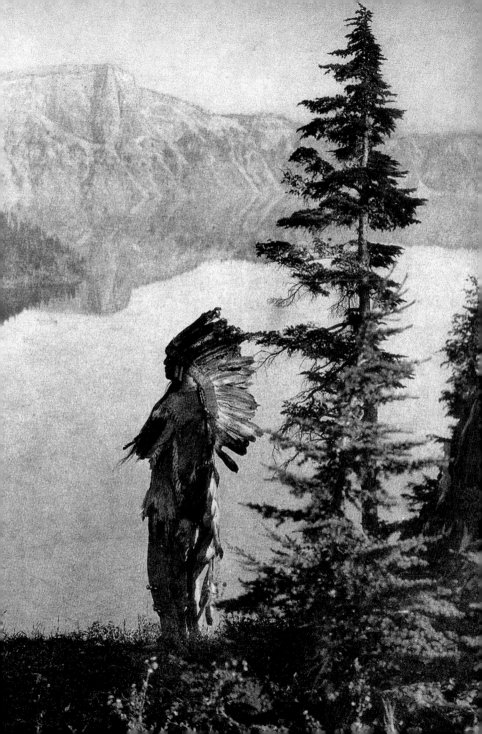

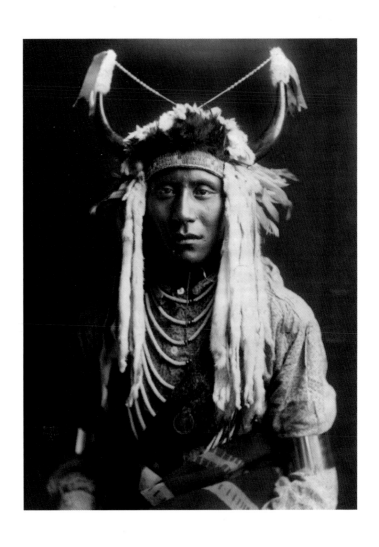

HEAD CARRY · PLATEAU, 1900

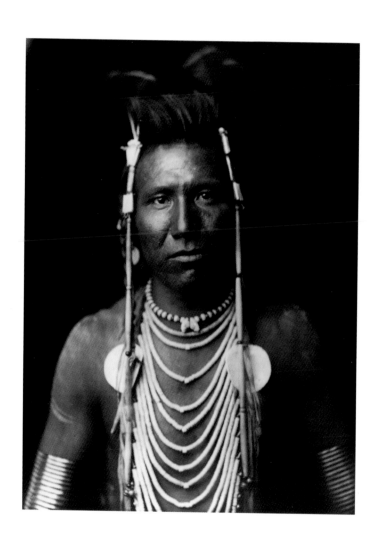

BEN LONG EAR, 1905

PLACATING THE SPIRIT OF A SLAIN EAGLE · ASSINIBOIN, 1926
Der Geist eines getöteten Adlers wird besänftigt | Apaisement de l'esprit d'un aigle tué

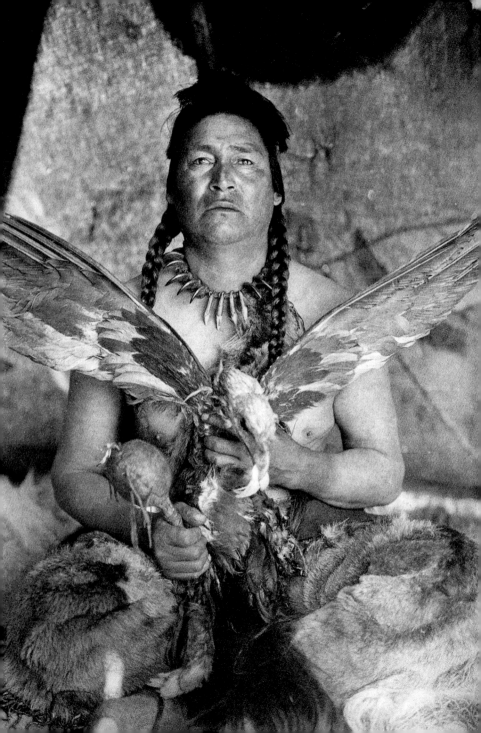

CHEYENNE
WARRIORS, 1905
Krieger der Cheyenne
Guerriers Cheyennes

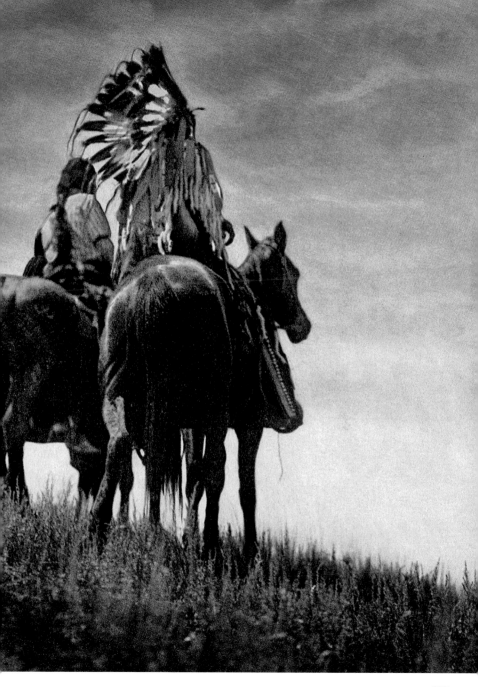

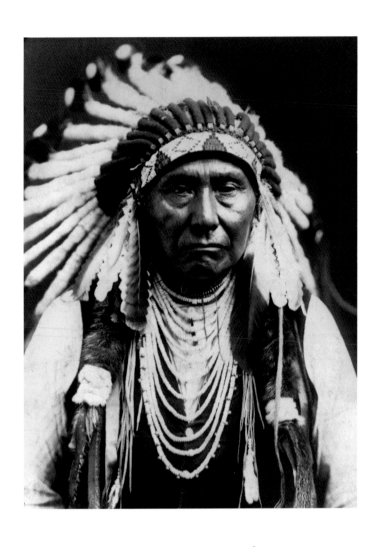

CHIEF JOSEPH · NEZ PERCÉ, 1903
Häuptling Joseph | Le Chef Joseph

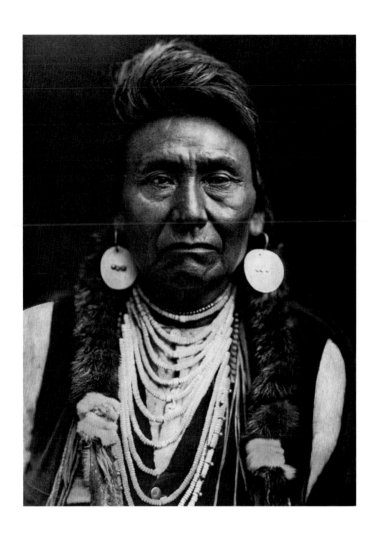

CHIEF JOSEPH · NEZ PERCÉ, 1903
Häuptling Joseph | Le Chef Joseph

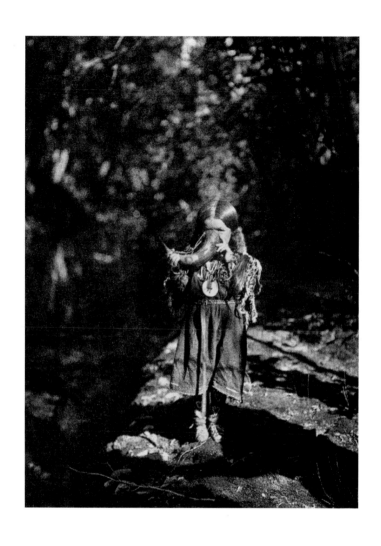

A DRINK · FLATHEAD, 1910
Eine Erfrischung | Rafraîchissement

FLATHEAD CHILDHOOD, 1910
Kindheit bei den Flathead | Enfance Flathead

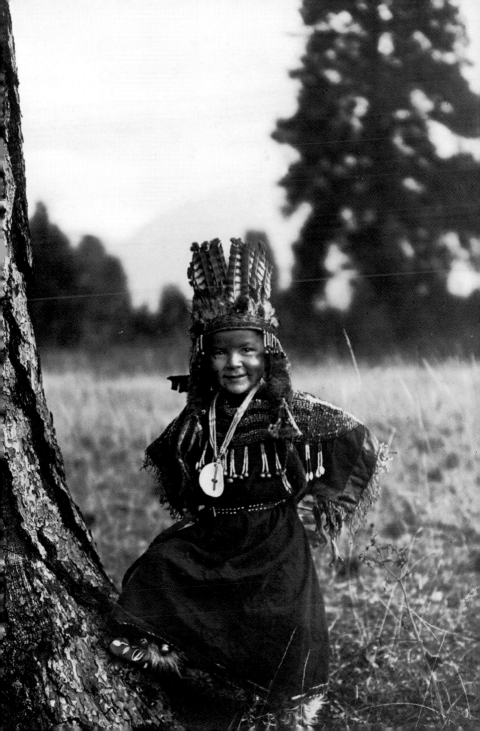

WATCHING THE DANCERS (WALPI) · HOPI, 1906
Ein Blick auf die Tänzer (Walpi) | En regardant les danseurs (Walpi)

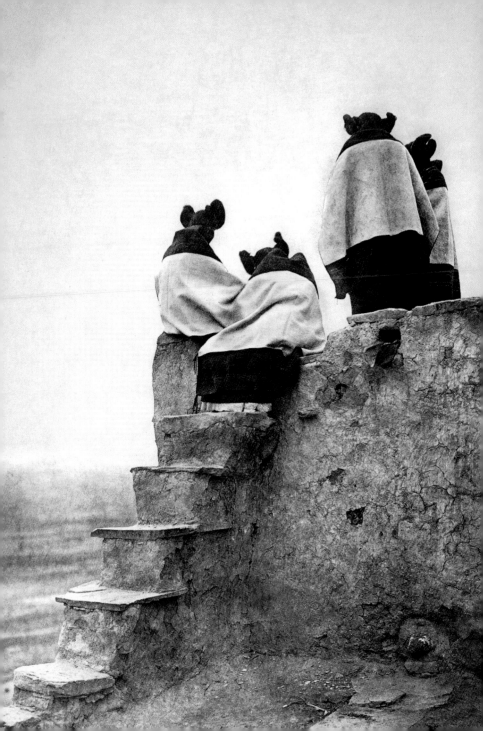

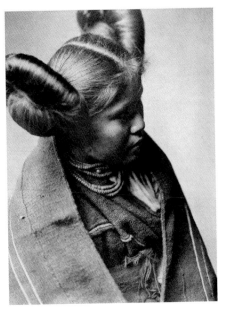 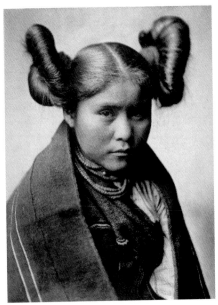

CHAIWA-TEWA-PROFILE, 1921
Ein Chaiwa-Tewa-Profil
Profil Chaiwa-Tewa

CHAIWA-TEWA, 1921

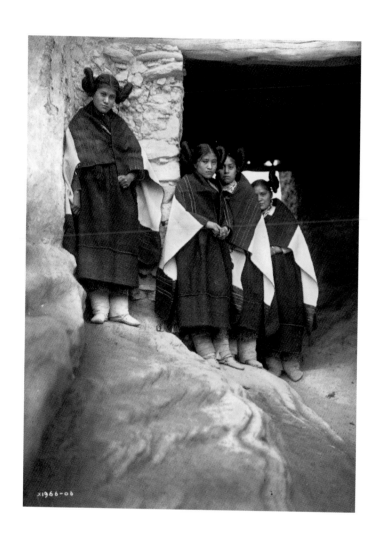

WALPI MAIDENS · HOPI, 1906

Unverheiratete Mädchen aus Walpi | Jeunes filles de Walpi

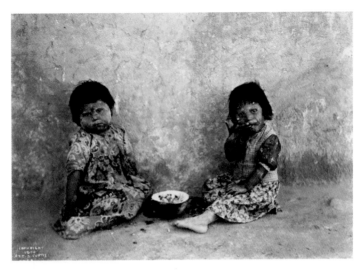

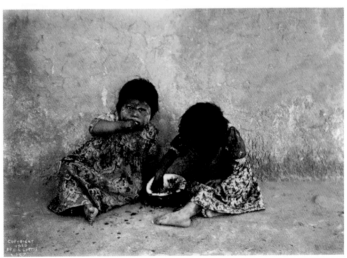

HOPI MELON EATERS, OR "THE DELIGHTS OF CHILDHOOD", 1900
Melonenesser bei den Hopi oder »Die Freuden der Kindheit«
Mangeurs de melon Hopi ou « Les délices de l'enfance »

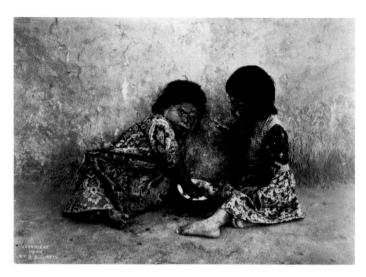

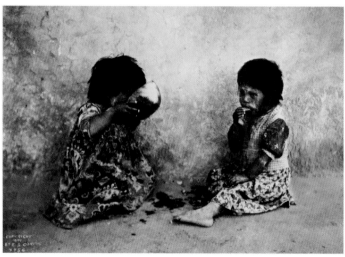

HOPI MELON EATERS, OR "THE DELIGHTS OF CHILDHOOD", 1900
Melonenesser bei den Hopi oder »Die Freuden der Kindheit«
Mangeurs de melon Hopi ou « Les délices de l'enfance »

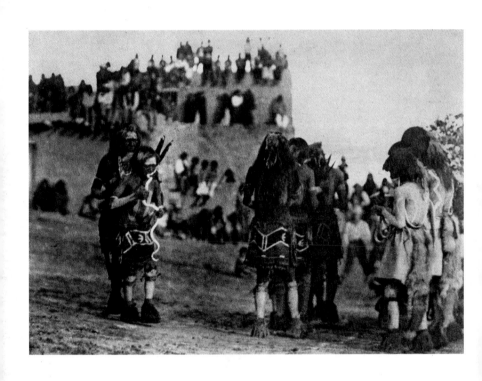

SNAKE DANCER AND "HUGGER", 1921

Schlangentänzer und »Hugger« | Danseur de la Danse du Serpent et « Hugger »

SINGING TO THE SNAKES · SHIPAULOVI, 1906

Gesang für die Schlangen | Charmeurs de serpents

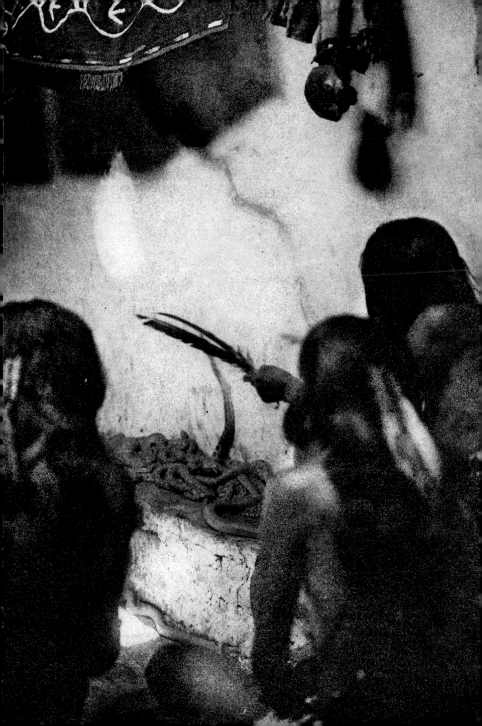

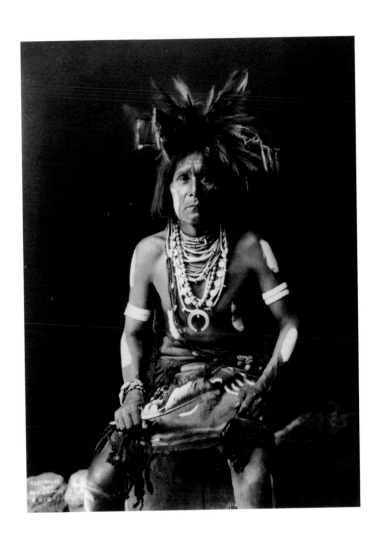

A SNAKE PRIEST OF THE ANTELOPE FRATERNITY · HOPI, 1921
Ein Schlangenpriester der Antilopen-Bruderschaft
Prêtre du Serpent appartenant à la confrérie de l'Antilope

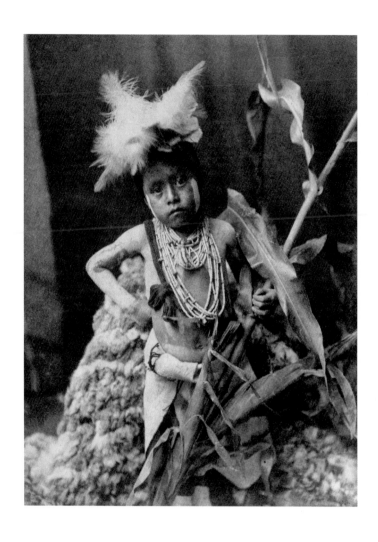

AWAITING THE RETURN OF THE SNAKE RACERS · HOPI, 1921
Die Rückkehr der Schlangenläufer wird erwartet
En attendant le retour des coureurs de serpents

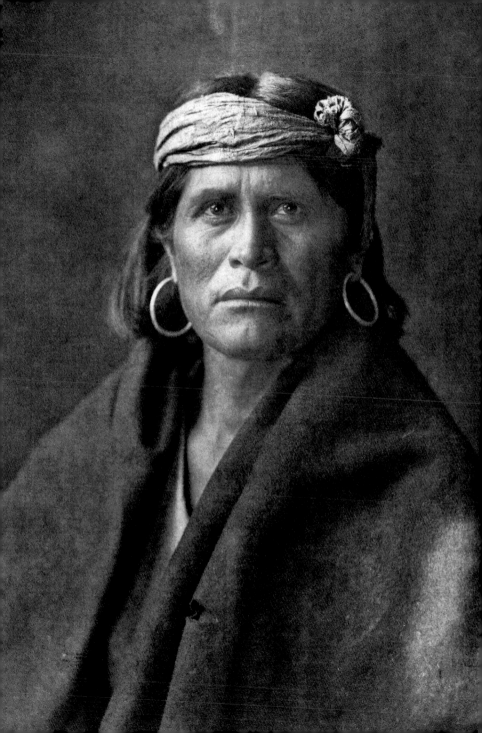

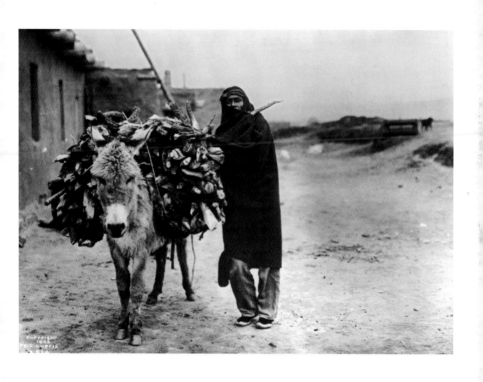

A LOAD OF FUEL, ZUÑI, 1903
Eine Fuhre Brennmaterial | Chargement de combustible

A WALPI MAN · HOPI, 1921
Walpi-Mann | Un homme Walpi

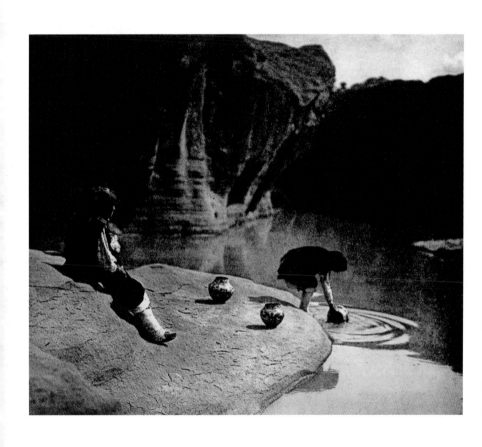

AT THE OLD WELL OF ACOMA, 1904
Am alten Brunnen von Acoma | Au vieux puits d'Acoma

TAOS WATER GIRLS, 1905
Wassermädchen aus Taos | Porteuses d'eau de Taos

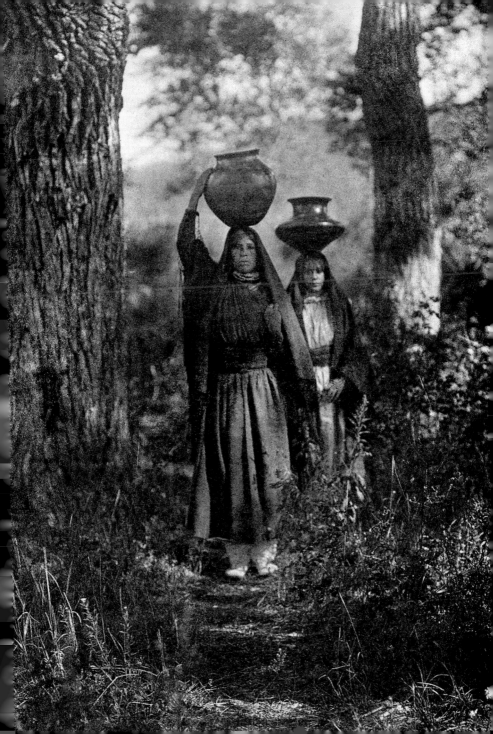

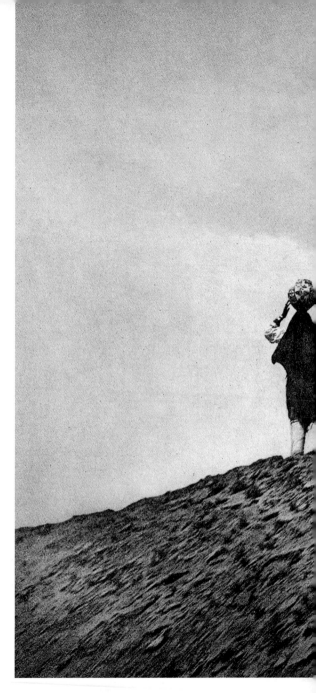

ACOMA WATER GIRLS,
1904
Wassermädchen von Acoma
Porteuses d'eau d'Acoma

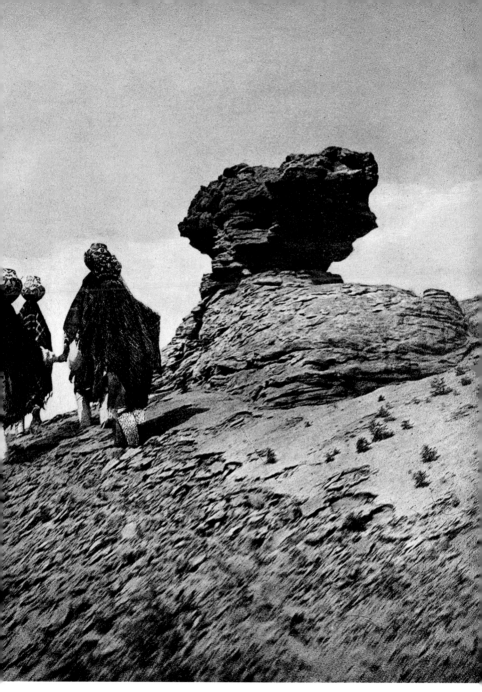

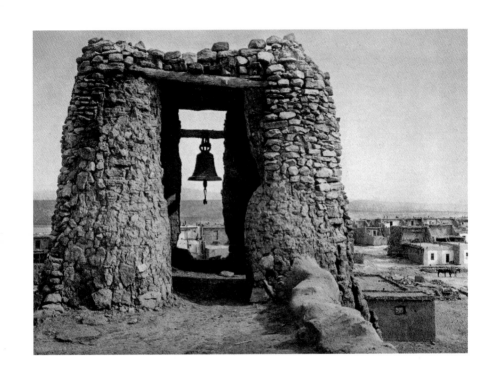

ACOMA BELFRY, 1904
Glockenstube in Acoma | Clocher d'Acoma

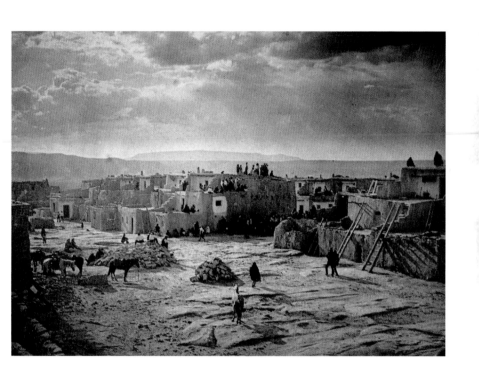

A FEAST DAY AT ACOMA, 1904
Ein Feiertag in Acoma | Jour de fête à Acoma

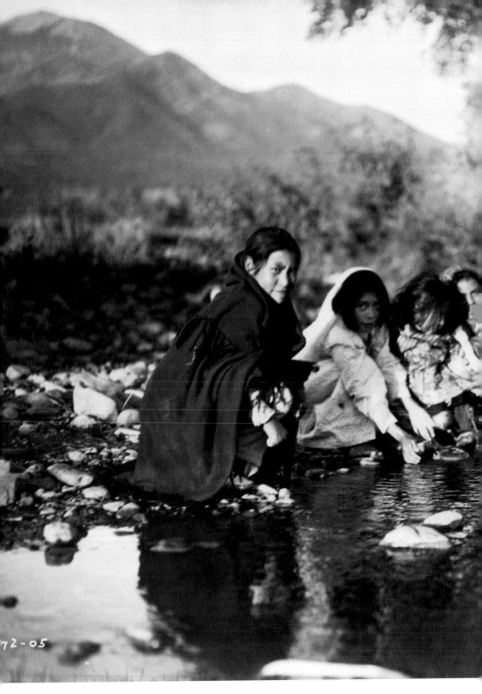

72-05

132

TAOS CHILDREN, 1905
Kinder aus Taos
Enfants de Taos

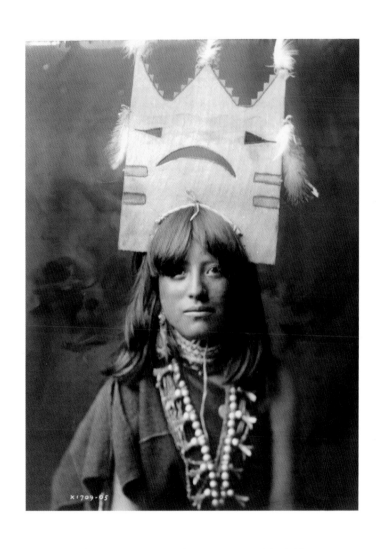

TABLITA WOMAN DANCER · SAN ILDEFONSO, 1905
Tablitatänzerin | Danseuse Tablita

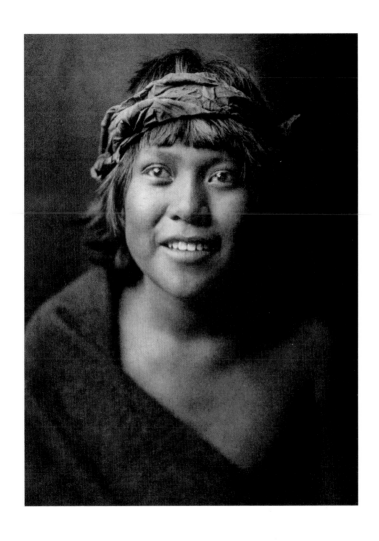

OKÚWA-TSIRÉ ("CLOUD-BIRD") · SAN ILDEFONSO, 1905

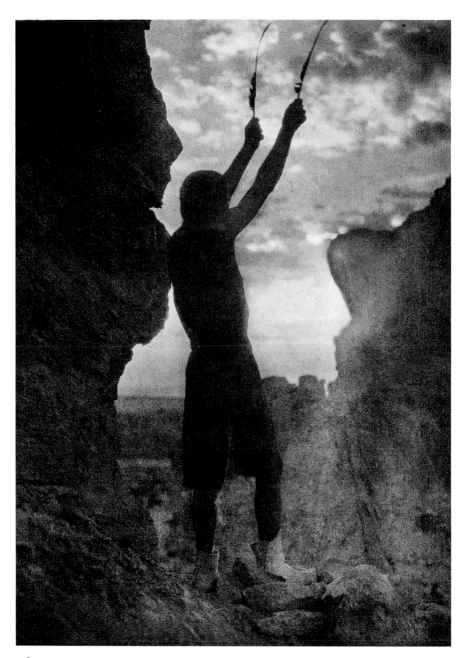

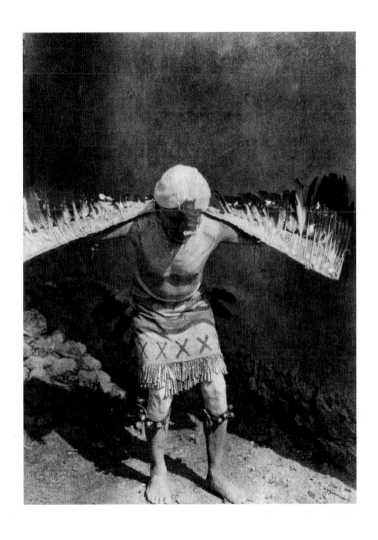

EAGLE DANCER · SAN ILDEFONSO, 1925
Adlertänzer | Danseur aigle

OFFERING TO THE SUN · SAN ILDEFONSO, 1925
Das Sonnenopfer | Offrande au soleil

MASKED DANCER · COWICHAN, 1912
Tänzer mit Maske | Danseur masqué

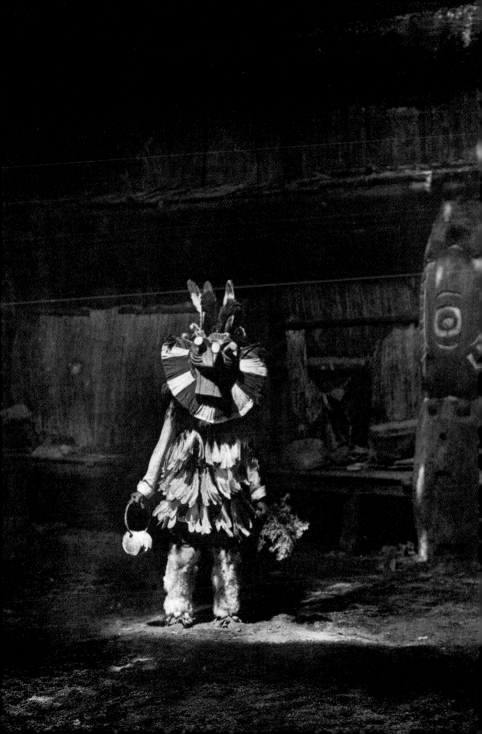

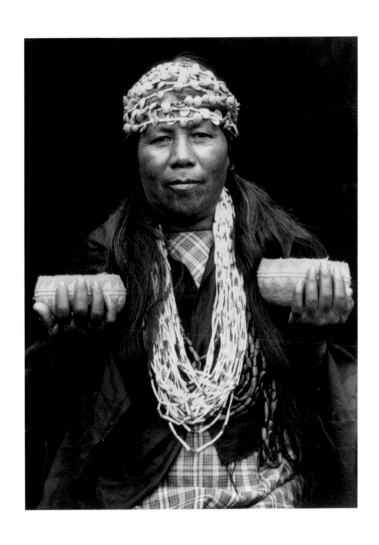

HUPA FEMALE SHAMAN, 1923
Schamanin der Hupa | Femme chaman Hupa

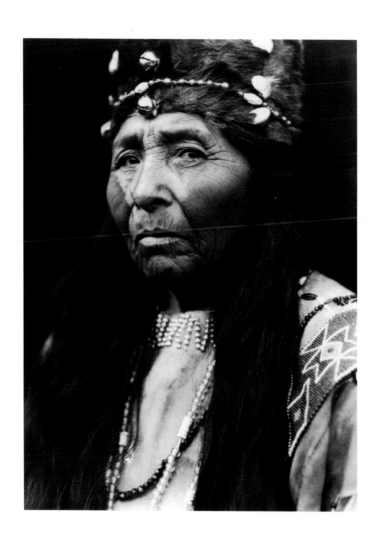

KLAMATH WOMAN, 1923
Klamathfrau | Femme Klamath

THE BOWMAN, 1915
Der Bogenschütze | L'archer

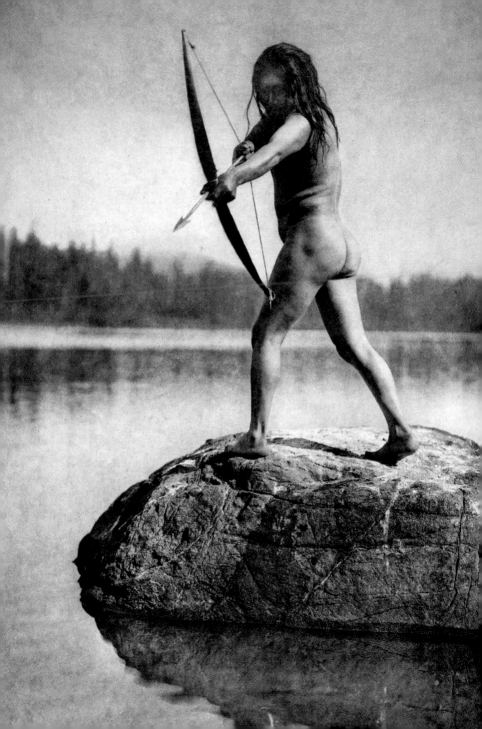

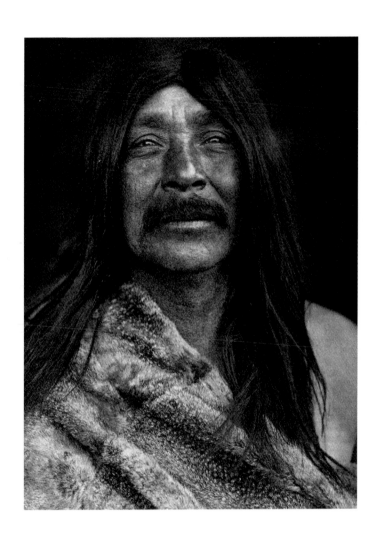

LÉLEHALT · QUILCENE, 1912

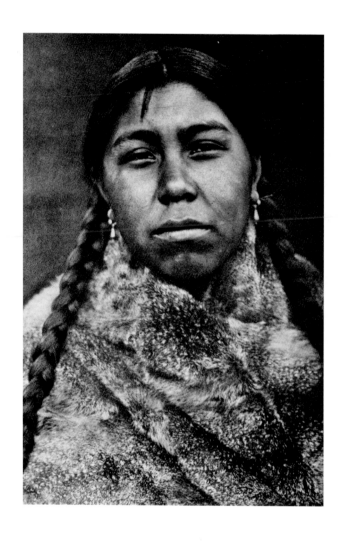

TSÁTSALATSA · SKOKOMISH, 1912

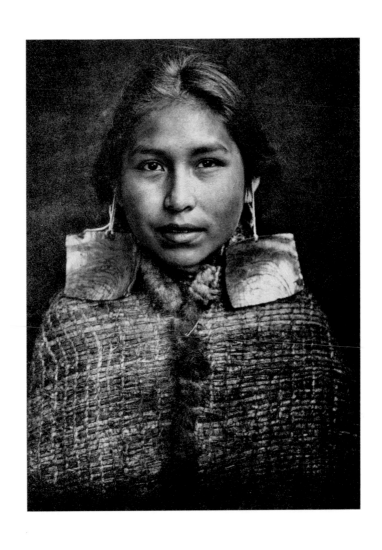

TSAWATENOK GIRL, 1914
Tsawatenokmädchen | Jeune fille Tsawatenok

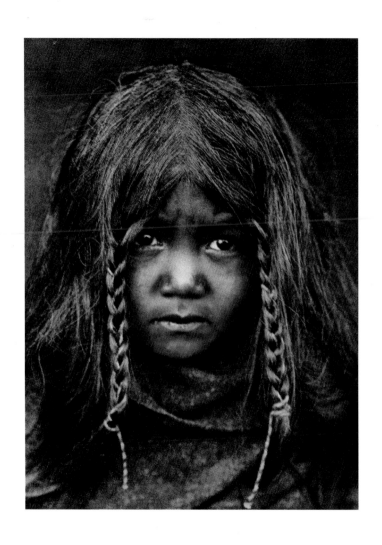

QUILCENE BOY, 1912
Quilcenejunge | Jeune garçon Quilcene

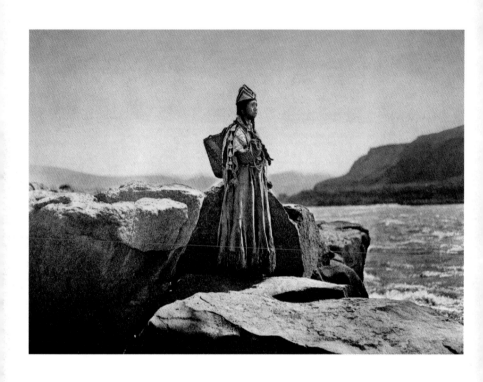

WISHRAM MAID, 1909
Unverheiratete Wishram | Jeune fille Wishram

THE FISHERMAN · WISHRAM, 1909
Der Fischer | Le pêcheur

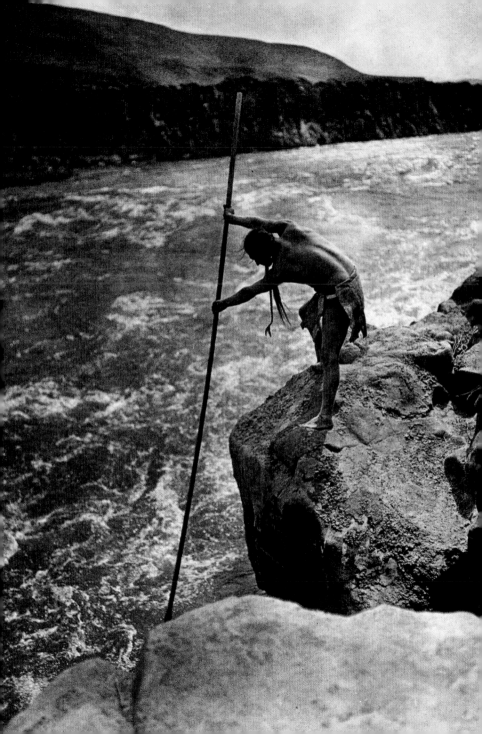

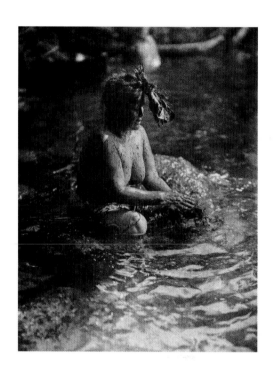

CEREMONIAL BATHING OF FEMALE SHAMAN
CLAYOQUOT, 1915
Das zeremonielle Bad einer Schamanin | Ablutions rituelles d'une femme chaman

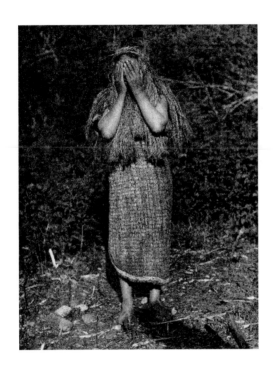

WOMAN SHAMAN LOOKING FOR CLAIRVOYANT VISIONS
CLAYOQUOT, 1915
Schamanin in Erwartung einer Vision | Femme chaman attendant des visions

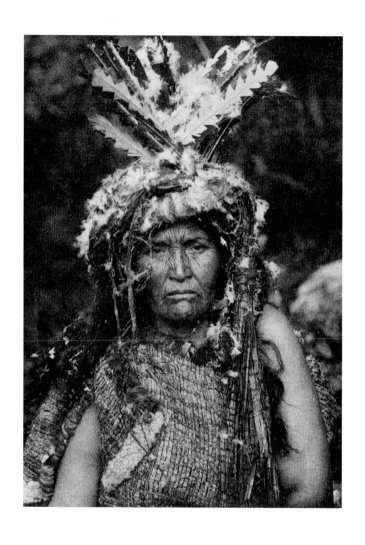

COSTUME OF A WOMAN SHAMAN · CLAYOQUOT, 1915
Kleidung einer Schamanin | Costume d'une femme chaman

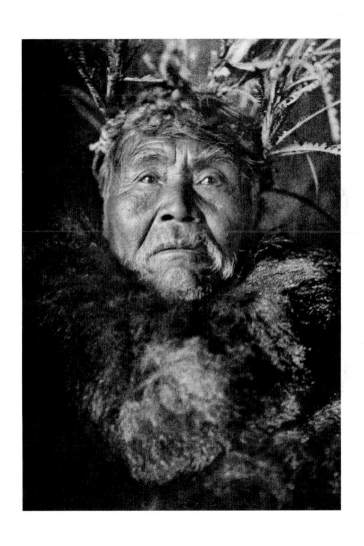

THE WHALER, 1915
Der Walfänger | Le baleinier

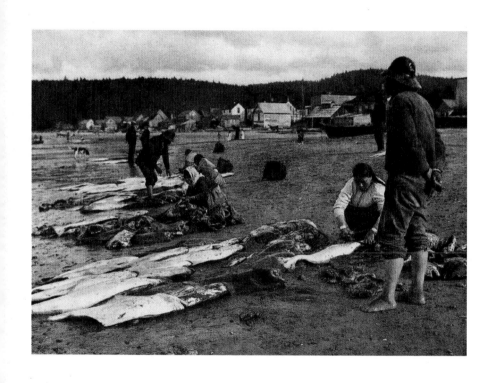

HALIBUT FISHERS · NEAH BAY, 1915
Heilbuttfischer | Pêcheurs de flétans

THE WHALER · MAKAH, 1915
Der Walfänger | Le baleinier

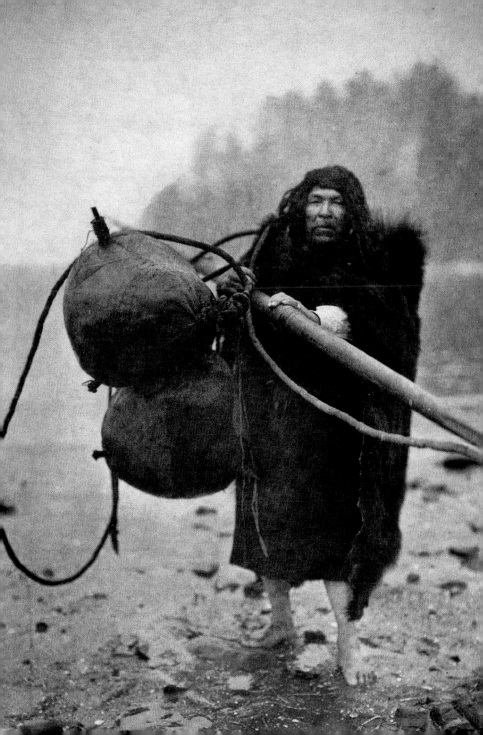

DANCING TO RESTORE
AN ECLIPSED MOON
QÁGYUHL, 1914
Tanz zur Wiedererlangung
des Mondes nach einer
Mondfinsternis
Danse pour ramener
une lune éclipsée

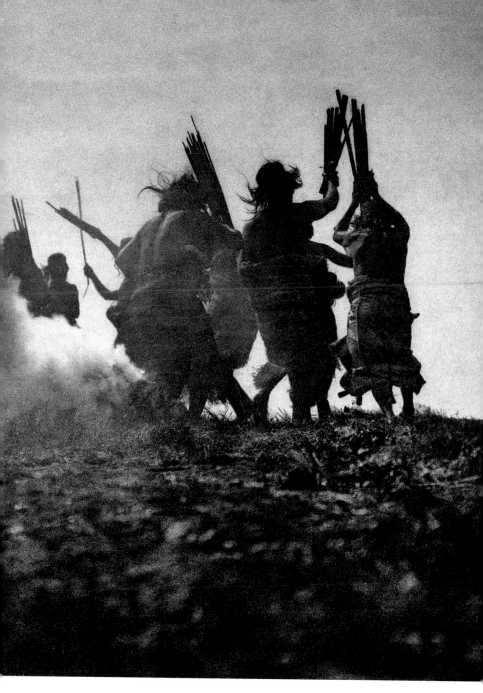

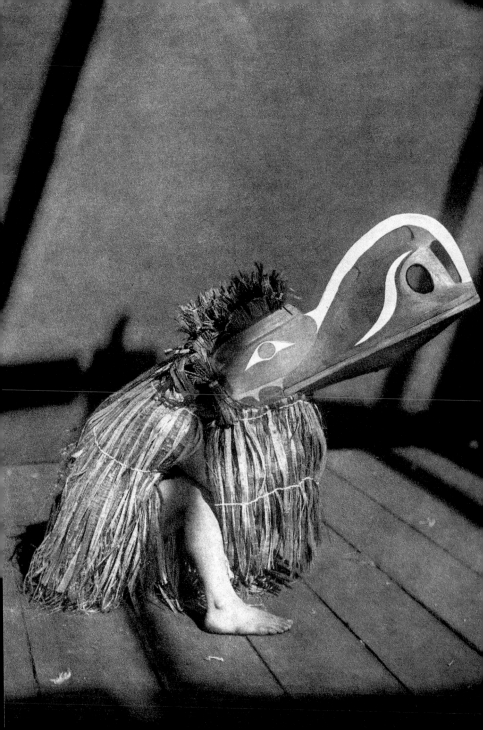

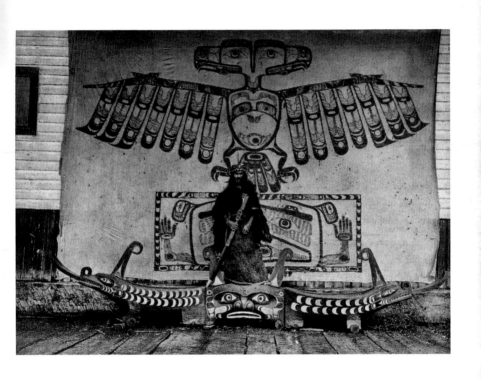

A NAKOAKTOK MÁWIHL, 1914
Ein Máwihl der Nakoaktok | Un Máwihl Nakoaktok

KALÓQUTSUIS · QÁGYUHL, 1914

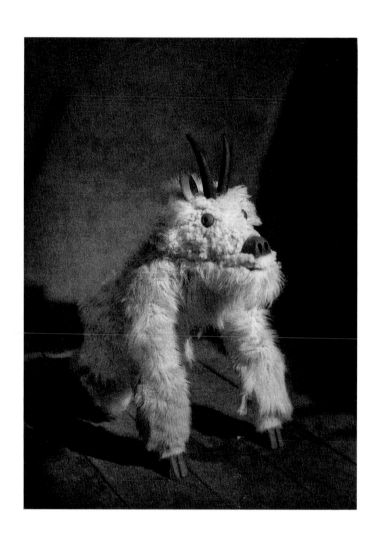

TAWIHYILAHL · QÁGYUHL, 1914

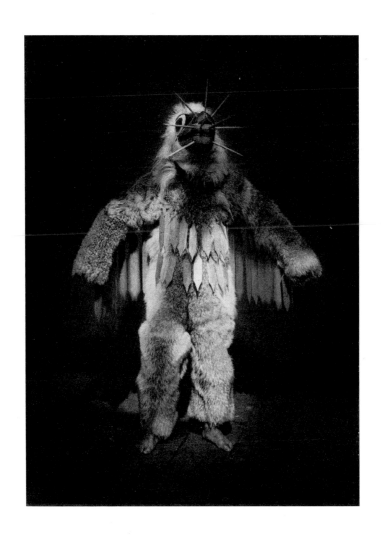

HAMASILAHL · QÁGYUHL, 1914

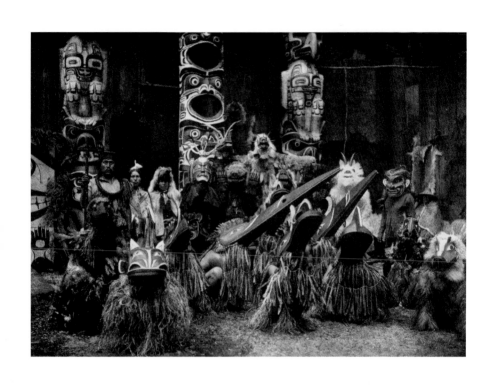

MASKED DANCERS · QÁGYUHL, 1914

Maskierte Tänzer | Danseurs masqués

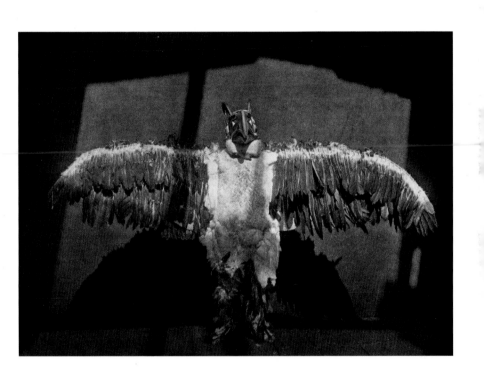

QÚNHUNAHL · QÁGYUHL, 1914

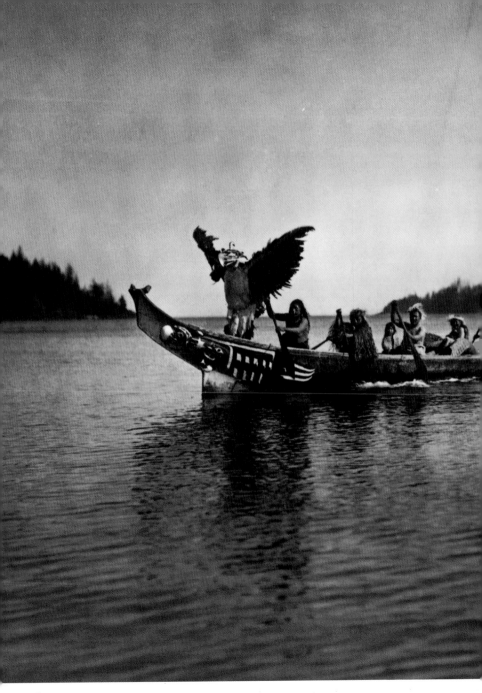

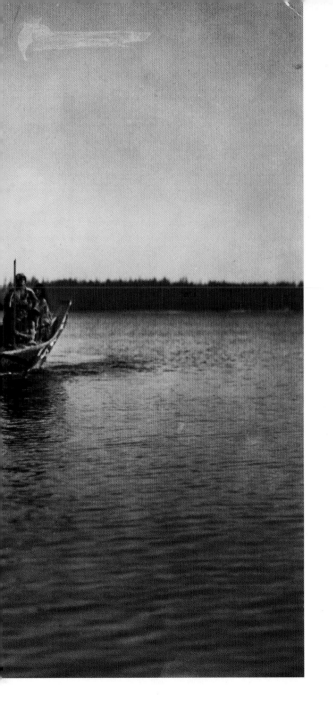

COMING FOR THE
BRIDE
QÁGYUHL, 1914
Die Braut wird geholt
En route vers la mariée

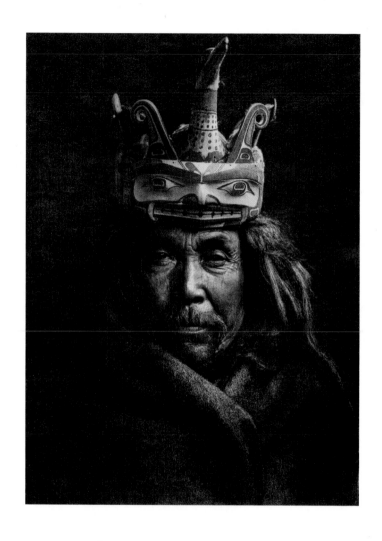

A TLU'WULAHU MASK · TSAWATENOK, 1914
Eine Tlu'wulahu-Maske | Masque Tlu'wulahu

A HAMATSA COSTUME · NAKOAKTOK, 1914
Ein Hamatsa-Kostüm | Costume Hamatsa

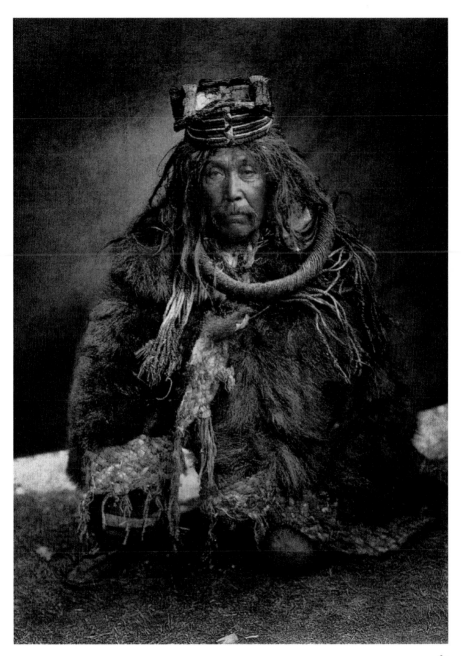

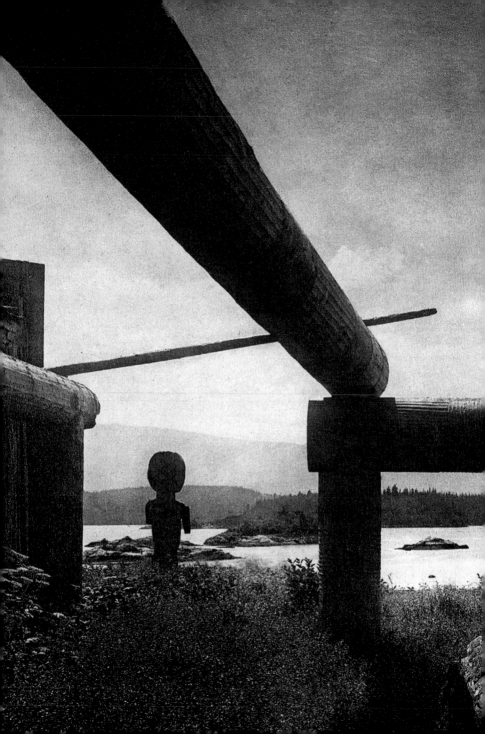

Pages | Seiten 168–169
KWAKIUTL HOUSE
FRAME, 1914
Balkenwerk eines Kwakiutl-
Hauses | Charpente de
maison Kwakiutl

A HAIDA CHIEF'S
TOMB AT YAN, 1915
Das Grabmal eines Haida-
Häuptlings in Yan | Tombe
de chef Haida à Yan

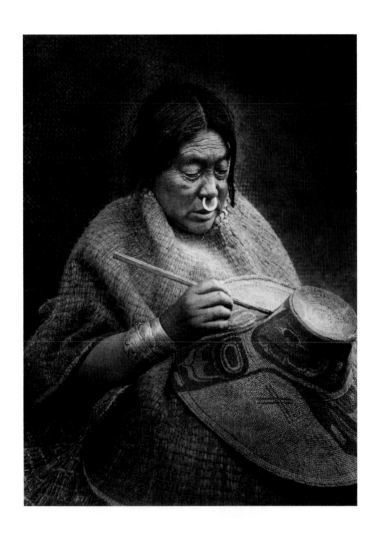

PAINTING A HAT · NAKOAKTOK, 1914
Das Bemalen eines Huts | Peinture d'un chapeau

A NAKOAKTOK CHIEF'S DAUGHTER, 1914
Häuptlingstochter der Nakoaktok | Fille d'un Chef Nakoaktok

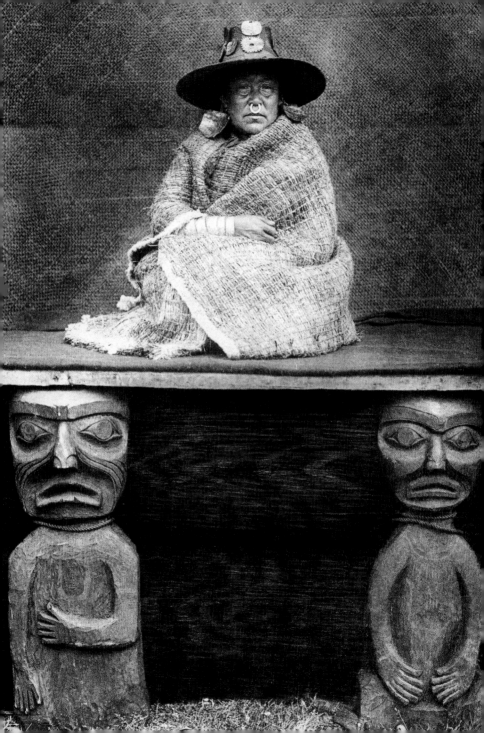

WOMAN AND CHILD · NUNIVAK, 1928
Mutter mit Kind | Femme et enfant

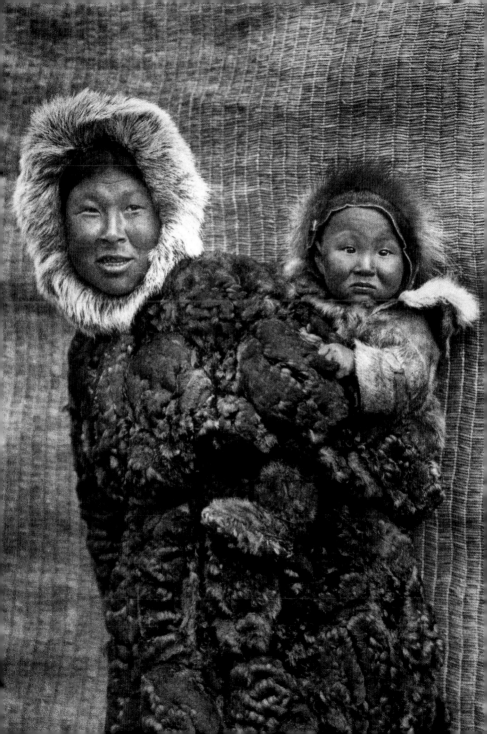

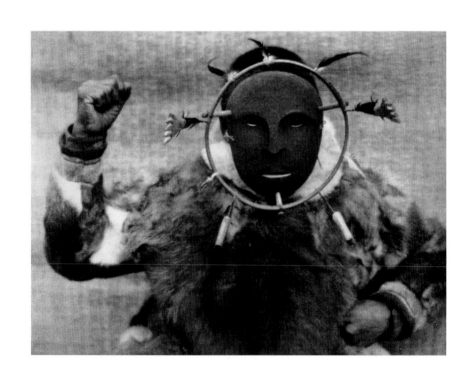

CEREMONIAL MASK · NUNIVAK, 1928

Zeremonienmaske | Masque de cérémonie

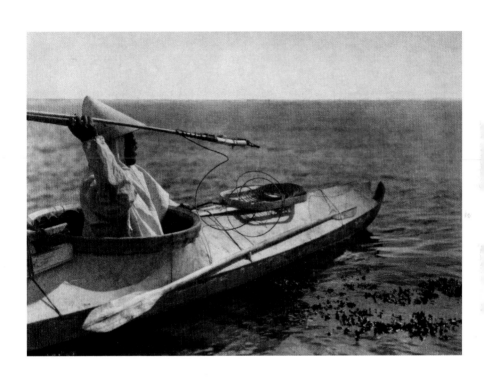

READY FOR THE THROW · NUNIVAK, 1928

Zum Wurf bereit | Prêt pour le lancer

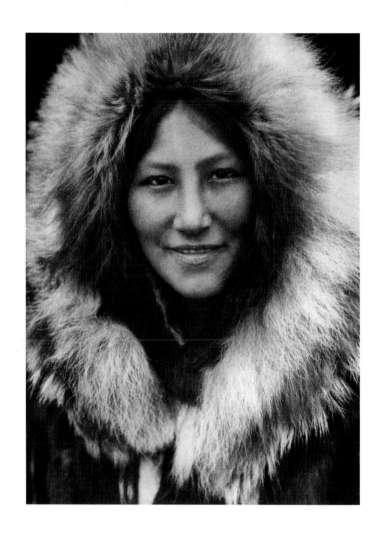

ÓLA · NOATAK, 1928

NOATAK CHILD, 1929
Kind der Noatak | Enfant Noatak

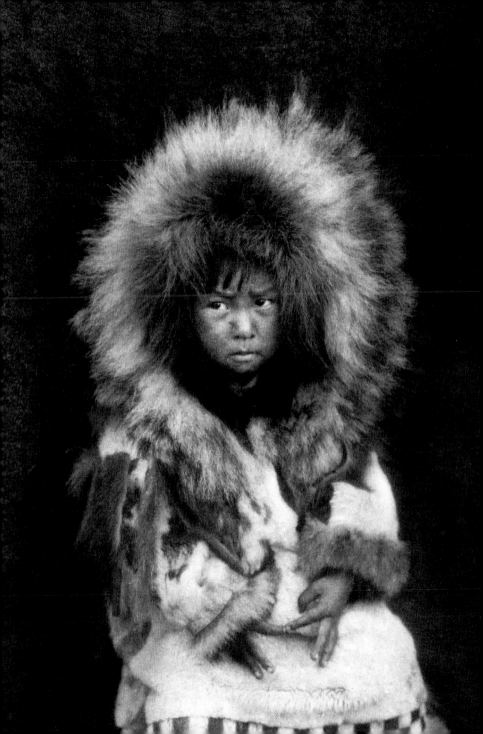

Edward S. Curtis, 1951
Photographer unknown

Photograph unbekannt

Photographe inconnu

On Custer's Outlook – Crow. Curtis,
2nd from right, with Crow scouts,
1908

Auf Custers Aussichtspunkt –
Crow. Curtis sitzt als Zweiter von
rechts zwischen den Crow-Scouts

Point de vue de Custer – Crow.
Curtis, 2ᵉ à partir de la droite, avec
des éclaireurs Crow

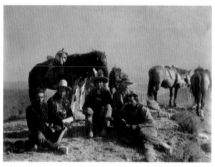

Curtis' studio on 4th Avenue
and University Street, Seattle,
Washington, ca. 1918

Das Studio von Curtis an der
4. Avenue und University Street
in Seattle, Washington

Le Studio Curtis sur la 4ᵉ Avenue
et University Street à Seattle,
Washington

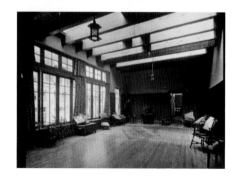

Biography | Biographie

Edward S. Curtis · 1868–1952

1868

Edward Sheriff Curtis is born on 16 February on a farm in Cold Springs, Jefferson County, Wisconsin, as the second of four children of the preacher Johnson Curtis and his wife, Ellen Sheriff Curtis.

Edward Sheriff Curtis wird am 16. Februar auf einer Farm in Cold Springs, Jefferson County, Wisconsin, als zweites von vier Kindern des Predigers Johnson und seiner Frau Ellen Sheriff Curtis geboren.

Naissance le 16 février d'Edward Sheriff Curtis dans un ranch de Cold Springs, Jefferson County, Wisconsin. Il est le second des quatre enfants du prédicateur Johnson et de son épouse Ellen Sheriff Curtis.

ca. 1885

After teaching himself the rudiments of photography, Edward Curtis becomes an apprentice in a photo studio in St. Paul, Minnesota.

Nachdem Edward Curtis zuvor autodidaktisch erste Erfahrung auf dem Gebiet der Photographie gesammelt hat, wird er Lehrling in einem Photostudio in St. Paul, Minnesota.

Après avoir acquis en autodidacte une première expérience photographique, il apprend les rudiments de la photographie dans un studio de St. Paul, Minnesota.

1887

Edward moves with his family to Sidney in Washington State, where his ailing father dies the following year.

Mit seiner Familie zieht Edward nach Sidney im Staate Washington, wo der kranke Vater im Jahr darauf stirbt.

Edward s'installe avec sa famille à Sidney, dans l'Etat de Washington, où son père malade décède l'année suivante.

ca. 1892

Edward Curtis becomes a partner in the photo studio run by Rasmus Rothi in Seattle, Washington.

Edward Curtis wird Partner im Photostudio von Rasmus Rothi in Seattle, Washington.

Edward Curtis devient associé du studio photo de Rasmus Rothi à Seattle, Washington.

1892

The photographer marries Clara Phillips. Various members of the Curtis and Phillips families work in Curtis' photographic business over the coming years.

Der Photograph heiratet Clara Phillips. Verschiedene Mitglieder der Familien Curtis und Phillips arbeiten in den folgenden Jahren in Edwards Photogeschäft mit.

Le photographe épouse Clara Phillips. Plusieurs membres des familles Curtis et Phillips collaborent, au cours des années suivantes, à l'entreprise photographique d'Edward.

1893

Curtis becomes a partner in Thomas Guptil's studio.

Curtis wird Partner im Atelier von Thomas Guptil.

Curtis s'associe à l'atelier de Thomas Guptil.

1895/96

Curtis takes his first Indian portrait at Puget Sound and in the Tulahip Reservation near Seattle.

Am Puget Sound und in der nahe Seattle gelegenen Tulahip Reservation nimmt der Photograph erste Indianerporträts auf.

Le photographe fait ses premiers portraits d'Indiens sur le Puget Sound et dans la réserve de Tulahip, dans les environs de Seattle.

Rabindranath Tagore (1861–1941),
1916

The Indian poet, philosopher and
Nobel Prize laureate, photographed
by the Curtis Studio in Seattle

Der indische Dichter, Philosoph
und Nobelpreisträger wurde im
Studio von Curtis in Seattle por-
trätiert

Le poète et philosophe indien
lauréat du Prix Nobel, photogra-
phié par le Studio Curtis de Seattle

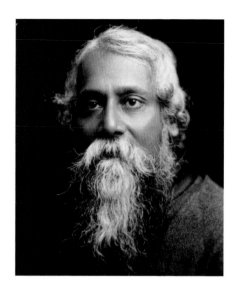

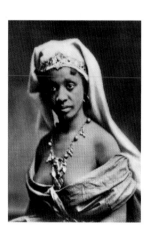

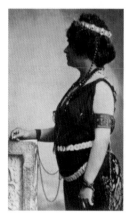

The Desert Queen, 1901
An example of Curtis' more exotic studio
work

Die Königin der Wüste
Ein Beispiel für eine ausgefallenere
Studioarbeit von Curtis

La Reine du Désert
Un exemple de travail de studio parmi
les plus exotiques de Curtis

The Egyptian, 1901
A society portrait by Curtis which brought
him considerable nationwide fame as a
portrait photographer

Die Ägypterin
Ein Gesellschaftsporträt von Curtis, das
ihm landesweiten Ruhm als Porträt-
photograph einbrachte

L'Egyptienne
L'un des portraits mondains de Curtis
qui lui valut quelque renom national en
tant que portraitiste

1897

Edward Curtis sets himself up as a self-employed "Photographer and Photoengraver", but soon drops the engraving side of his business. Curtis becomes Seattle's leading society photographer, also enjoying a nationwide reputation for his portraits. In addition, he devotes himself to landscape photography, taking shots of the mountains of the north-west coast, such as the Cascades and the Olympic Ranges. As a mountaineer, he delights also in Mount Rainier, a peak in Seattles's "own backyard".

Edward Curtis macht sich selbstständig und firmiert unter »Edward S. Curtis, Photographer and Photoengraver«, wobei er das Gravurgeschäft bald wieder aufgibt. Curtis wird zum führenden Gesellschaftsphotographen in Seattle und genießt auch national einen Ruf als anerkannter Porträtist. Darüber hinaus widmet er sich der Landschaftsphotographie und nimmt an der Nordwestküste Gebirgszüge wie die Cascades und Olympic Ranges auf. Als Bergsteiger begeistert er sich zudem für den »Hausberg« Seattles, den Mount Rainier.

Edward Curtis se met à son compte et se donne pour raison sociale « Edward S. Curtis, Photographer and Photoengraver », même s'il abandonne peu après la gravure. Curtis devient le premier photographe mondain de Seattle et jouit également d'un grand renom de portraitiste à l'échelon national. Il se consacre en outre à la photographie de paysage et des chaînes de montagnes de la côte nord-ouest, comme celles des Cascades ou de l'Olympic Ranges. Par ailleurs, il se passionne en tant qu'alpiniste pour le Mont Rainier, la « montagne maison » de Seattle.

1899

Curtis is invited to accompany the railway magnate Harriman on his expedition to Alaska. During the journey, he gets to know several prominent scientists, who introduce the autodidact to the world of science, awakening his interest in ethnology.

Curtis wird eingeladen, an der Alaska-Expedition des Eisenbahnmagnaten Harriman teilzunehmen. Er lernt auf dieser Reise bekannte Forscher kennen, die den Autodidakten in die Welt der Wissenschaften einführen und sein ethnologisches Interesse wecken.

Curtis est invité à participer à l'expédition en Alaska organisée par le magnat des chemins de fer Harriman. Il fait au cours de ce voyage la connaissance de célèbres explorateurs qui initient l'autodidacte à l'univers des sciences et éveillent son intérêt pour l'ethnologie.

1900

He conceives of the plan to photographically document Indian life, to record the tribes' oral tradition, their legends and stories, to note down the biographies of the most renowned chiefs and warriors, to study the Indian languages, and to record tribal songs with a view to transcribing them later into musical notation.

Curtis photographiert den Sonnentanz (»Sun Dance«) von Blood-, Blackfeet- und Algonquin-Indianern bei Browning, Montana. Er entwickelt den Plan, das Leben der Indianer photographisch zu dokumentieren, die mündlichen Überlieferungen der Stämme, ihre Legenden und Geschichten sowie die Biographien der berühmtesten Häuptlinge und Krieger festzuhalten, Sprachstudien zu betreiben und Gesänge aufzuzeichnen, um sie später in Noten zu transkribieren.

Curtis photographie la Danse du Soleil (« Sun Dance ») des Indiens Blood, Blackfeet et Algonquin dans les environs de Browning, Montana. Il conçoit le projet de documenter la vie des Indiens par la photographie, de consigner les traditions orales des tribus, leurs légendes et leurs histoires, de fixer par écrit les biographies des chefs et des guerriers les plus célèbres, d'étudier leurs langues et d'enregistrer leurs chants pour les transcrire plus tard dans des partitions.

1903

From this year on Curtis looks for funding for his project, which is entitled *The North American Indian*. He gives numerous lec-

Für sein Forschungsprojekt, das den Titel *The North American Indian* trägt, sucht Curtis ab 1903 Geldgeber. Er hält zahlreiche Vor-

A partir de 1903, Curtis recherche des bailleurs de fonds pour financer son projet de recherche, intitulé *The North American Indian*. Il

*Seattle society ladies dressed up
as Indian squaws by Curtis in his
studio.*
"*The Seattle Sunday Times*",
3 November 1912

Die Damen der Gesellschaft
von Seattle wurden von Curtis
in seinem Studio als indianische
Squaws verkleidet. *The Seattle
Sunday Times*, 3. November 1912

Dames de la société de Seattle
habillées en squaws indiennes,
photographiées par Curtis dans
son studio. *The Seattle Sunday
Times*, 3 novembre 1912

*An Indian profile, crossed arrows
and a tipi. This design was embossed
on the mounts of portraits done in
Curtis' studio, undated, ca. 1910*

Indianerprofil, gekreuzte Pfeile
und ein Tipi. Dieser Prägestempel
wurde für die auf Karton aufgezo-
genen Studioporträts verwendet,
nicht datiert, ca. 1910

Indien de profil, flèches croisées
et tipi, c'est le cachet en usage sur
les supports cartonnés des por-
traits du Studio Curtis, non daté,
vers 1910

tures throughout the USA and visits many Indian tribes.

1904
Curtis takes a portrait of President Theodore Roosevelt, in the process gaining an important backer for his project.

1906
The New York industrialist, financier and philanthropist John Pierpont Morgan funds Curtis' book project.

1907
The first volume of *The North American Indian* appears. It meets with praise from the critics, but the sales figures remain low. Despite permanent financial difficulties and interruptions caused by war, Curtis continues his work on his project until 1930. Supported by a team of assistants, he visits numerous Indian tribes from the Mexican Border to the Bering Sea, and from the Pacific coast to the Mississippi.

1914
Curtis shoots *In the Land of the Headhunters*, a silent feature film about the Indians of the north-west coast. The film later acts as a model for such ethnographically-minded feature film directors as Robert Flaherty.

1920
After his divorce, Curtis settles in Los Angeles and earns his living as a still photographer and camera-man for the Hollywood studios.

träge in den USA und besucht viele Indianerstämme.

Curtis porträtiert den Präsidenten Theodore Roosevelt und gewinnt mit ihm einen prominenten Förderer seines Projektes.

Der New Yorker Großindustrielle, Finanzier und Philanthrop John Pierpont Morgan fördert Curtis' Buchprojekt.

Der erste Band des *North American Indian* erscheint und wird von der Kritik gelobt. Die Verkaufszahlen bleiben jedoch niedrig. Curtis arbeitet trotz permanenter Finanzierungsschwierigkeiten und kriegsbedingter Unterbrechung bis 1930 weiter an dem Projekt. Unterstützt von einem Mitarbeiterteam besucht er zahlreiche Indianerstämme von der mexikanischen Grenze bis zum Bering-Meer und von der Pazifikküste bis zum Mississippi.

Curtis dreht den Stummfilm *In the Land of the Headhunters* (Im Land der Kopfjäger) über die Indianer der Nordwestküste. Dieser Film sollte späteren ethnologisch orientierten Spielfilmregisseuren wie Robert Flaherty als Vorbild dienen.

Nach seiner Scheidung läßt sich Curtis in Los Angeles nieder und finanziert seinen Lebensunterhalt als Standbildphotograph und Kameramann für die Hollywood Studios.

fait de nombreuses conférences à travers les Etats-Unis et rend visite à un grand nombre de tribus indiennes.

Curtis fait le portrait du président Theodore Roosevelt, en qui il gagne un éminent défenseur de son projet.

Le grand industriel, financier et philanthrope new-yorkais John Pierpont Morgan soutient le projet de livre de Curtis.

A sa parution, le premier volume de *North American Indian* est encensé par la critique. Le chiffre des ventes reste cependant peu élevé. Malgré des difficultés financières permanentes et une interruption liée à la guerre, Curtis continue jusqu'en 1930 de travailler à son projet. Avec le soutien d'une équipe de collaborateurs, il rend visite aux nombreuses tribus indiennes qui vivent entre la frontière mexicaine et la mer de Béring, et entre la côte du Pacifique et le Mississippi.

Curtis tourne le film muet *In the Land of the Headhunters* (Au pays des chasseurs de têtes) sur les Indiens de la côte nord-ouest. Ce film devait par la suite servir de modèle à des réalisateurs de films à orientation ethnologique comme Robert Flaherty.

Après son divorce, Curtis s'installe à Los Angeles où il gagne sa vie comme opérateur et photographe de plateau pour les studios d'Hollywood.

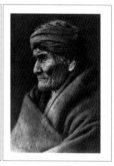

THE NORTH AMERICAN INDIAN

by Edward Sheriff Curtis. 20 vols.;
vols. I–V, Cambridge (MA): The
University Press; vols. VI–XX,
Norwood (MA): The Plimpton
Press, 1907–1930.

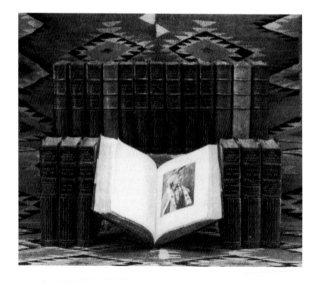

1928
After an eventful journey to the Arctic, Curtis concludes his researches for *The North American Indian*.

Nach einer abenteuerlichen Arktisreise schließt Curtis die Recherchen für *The North American Indian* ab.

Après un voyage mouvementé dans l'Arctique, Curtis clôt ses recherches pour *The North American Indian*.

from 1930
The 20ᵗʰ and final volume of *The North American Indian* appears. Shortly afterwards, Curtis withdraws into private life, but for many years he continues work on a book with the working title *The Lure of Gold*. The book never appears.

Volume XX, der letzte Band von *The North American Indian*, erscheint. Curtis zieht sich bald darauf ins Privatleben zurück, arbeitet jedoch noch viele Jahre an einem Buch mit dem Arbeitstitel *The Lure of Gold* (Der Lockruf des Goldes), das nie erscheinen sollte.

Parution du XXᵉ et dernier volume de *The North American Indian*. Curtis se retire peu de temps après pour se consacrer à sa vie privée, mais il travaille encore plusieurs années à un livre intitulé provisoirement *The Lure of Gold* (L'appel de l'or), et qui ne verra jamais le jour.

1952
On 19 October Edward Sheriff Curtis dies in Los Angeles of a heart attack.

Edward Sheriff Curtis stirbt am 19. Oktober nach einem Herzanfall in Los Angeles.

Edward Sheriff Curtis meurt le 19 octobre à Los Angeles d'une crise cardiaque.

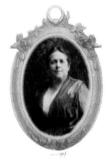

Early portrait from the Curtis & Guptil studio, Seattle, ca. 1892
Frühe Porträtarbeit aus dem Curtis & Guptil-Studio, Seattle, ca. 1892
Portrait des débuts du Studio Curtis & Guptil, Seattle, vers 1892

Mrs S. E. S. Meany, ca. 1910
Portrait from Curtis' studio. The frame-like vignette is photographically printed and not three-dimensional
Mrs S. E. S. Meany, ca. 1910
Porträt aus dem Studio von Curtis. Die rahmenähnliche Vignette wurde wie ein Foto gedruckt und ist nicht dreidimensional
Mme S. E. S. Meany, vers 1910
Portrait du Studio Curtis. Le cadre avec ses bords estompés est imprimé par procédé photographique et n'est pas en trois dimensions

Young lady with palms, 1920s
An example of Curtis' Los Angeles studio work. The photo is a framed "orotone" or goldtone print
Junge Dame mit Palme, 1920er
Ein Beispiel der Studioarbeit von Curtis in Los Angeles. Es handelt sich um ein gerahmtes »Orotone«
Jeune dame au palmier, années 1920
Un exemple du travail du Studio Curtis de Los Angeles. Il s'agit d'une épreuve obtenue par virage à l'or

Photographic credits

Bildnachweis | Crédits photographiques

Most of the images derive from Curtis' encyclopaedic work *The North American Indian*, 1907–1930 (abbreviated to: NAI). All the illustrations from NAI have been reproduced from the complete set of NAI (designated set number 8) in the possession of the Niedersächsischen Staats- und Universitätsbibliothek in Göttingen. In the 20 textual volumes of NAI, the gravure illustrations have no page or plate numbers. The photos reproduced from NAI are identified by giving the NAI vol. no. followed by the page no. nearest to the gravure print, abbreviated, e. g. as follows: vol. X, p. 56. The 20 textual volumes of NAI are accompanied by 20 portfolios of gravure-printed photographs. Here, photos reproduced from the portfolios (abbreviated to: folio) are identified by giving the relevant volume and plate number, e. g.: NAI folio X, pl. 356.

Photos reproduced from material held by the Department of Prints and Photographs of the Library of Congress, Washington DC, (abbreviated to: LC), are identified with LC and the relevant negative number.

Photos reproduced from material held by the University of Washington Libraries, Seattle, WA, (abbreviated to: UW), are likewise identified by their negative number.

Picture material has also kindly been supplied by the Seattle gallery Flury and Company (abbreviated to: Flury), which specializes in Curtis photographs.

Die meisten Abbildungen im vorliegenden Buch stammen aus Curtis' Werk *The North American Indian*, 1907–1930 (abgekürzt: NAI). Als Reproduktionsvorlage diente die mit Nr. 8 bezeichnete vollständige Ausgabe des Titels, die sich im Besitz der Niedersächsischen Staats- und Universitätsbibliothek in Göttingen befindet. Die Abbildungen in den 20 Textbänden der NAI sind weder durch Seitenzahlen noch durch Abbildungsnummern gekennzeichnet. Im Abbildungsverzeichnis ist die Seitenzahl angegeben, die der Abbildung am nächsten steht, abgekürzt z. B.: vol. X, p. 56. Für die 20 Portfolios (abgekürzt folio) der NAI mit Photogravüren erfolgt die Bezeichnung der Abbildung nach Bandzahl und Nummer der Bildtafel (pl. für plate), abgekürzt z. B.: NAI folio X, pl. 356.

Die Bildvorlagen vom Department of Prints and Photographs of the Library of Congress, Washington, DC, (Abkürzung: LC) sind mit der Nummer des Negativs aufgeführt.

Das Abbildungsmaterial der University of Washington Libraries in Seattle (abgekürzt: UW) ist ebenfalls mit der Negativnummer verzeichnet.

Die auf Curtis-Photographien spezialisierte Galerie Flury and Company in Seattle (abgekürzt: Flury) stellte ebenfalls Bildmaterial zur Verfügung.

La plupart des illustrations proviennent de l'œuvre de Curtis *The North American Indian*, 1907–1930 (en abrégé NAI.). Les reproductions figurant dans le présent volume ont été réalisées à partir de l'édition complète, répertoriée sous le n° 8, qui se trouve en possession de la Niedersächsische Staats- und Universitätsbibliothek de Göttingen. Les planches des 20 volumes des NAI. ne font l'objet d'aucune pagination, que ce soit sous la forme de numéros de page ou d'illustration. Le numéro de page qui figure dans la table des illustrations est celui de la page la plus proche de l'illustration en question, soit par exemple : vol. X, p. 56. En ce qui concerne les 20 portfolios (en abrégé folio) de photogravures qui accompagnent les volumes des NAI., ce sont les numéros du volume et de la planche qui servent à identifier les illustrations, soit par exemple : NAI folio X, pl. 356.

Les photos du département des imprimés et des photographies de la Library of Congress de Washington DC (en abrégé LC) sont mentionnés par le numéro du négatif.

Le matériau photographique en provenance de l'University of Washington Libraries de Seattle (en abrégé UW) est lui aussi désigné par le numéro du négatif.

L'éditeur remercie également la Galerie Flury and Company de Seattle (en abrégé Flury), spécialisée dans l'œuvre de Curtis, qui a bien voulu mettre des photographies à sa disposition.

l. = left | links | à gauche
r. = right | rechts | à droite
t. = top | oben | ci-dessus
c. = centre | Mitte
b. = bottom | unten | ci-dessous

Page | Seite:
6 LC-USZ62-57487; 7 LC-USZ62-112209; 8 LC-USZ62-109702; 9 Flury; 10 NAI folio VI, pl. 196; 11 NAI folio VI, pl. 213; 12 NAI folio IV, pl. 120; 13 NAI folio V, pl. 153; 14 NAI folio XVIII, pl. 640; 15 NAI folio XIV, pl. 472; 16 NAI folio V, pl. 180; 17 NAI folio I, pl. 21; 33 LC-USZ62-116676 (also NAI folio I, pl. 28); 35 Flury (goldtone same as gravure in NAI folio I, pl. 1); 36 NAI vol. I, p. 52; 37 NAI vol. I, p. 64; 38 NAI vol. I, p. 52; 39 NAI folio I, pl. 14; 40 Flury (goldtone same as NAI folio I, pl. 20); 41 NAI folio I, pl. 32; 42 NAI folio I, pl. 15; 43 NAI folio VIII, pl. 266; 44–45 NAI vol. I, p. 66; 46 NAI vol. I, p. 36; 47 NAI folio III, pl. 76; 48 NAI vol. I, p. 136; 49 NAI vol. I, p. 110; 50 NAI vol. I, p. 94; 51 NAI vol. I, p. 102; 52 NAI folio XVIII, pl. 633; 54 LC-USZ62-83601 (also NAI folio II, pl. 56); 55 NAI folio II, pl. 61; 56 LC-USZ62-105385 (also NAI folio XIII, pl. 451); 57 NAI folio XIII, pl. 445; 58–59 NAI vol. IV, p. 116; 60–61 LC-USZ62-46970 (also NAI folio IV, pl. 127); 62 NAI vol. I, p. 140; 63 NAI vol. I, p. 138; 65 NAI folio III, pl. 108; 66 NAI folio IV, pl. 125; 67 NAI folio III, pl. 85; 68 NAI folio I, pl. 21; 69 NAI folio III, pl. 104; 70 NAI vol. IV,

p. 78; 71 Flury (goldtone print s. also NAI vol. IV, frontispiece); 72 NAI vol. IV, p. 166; 73 NAI vol. IV, p. 150; 74 NAI vol. IV, p.74; 75 NAI vol. IV, p.136; 76–77 Flury (goldtone print, also NAI folio III, pl. 80); 78–79 NAI folio III, pl. 111; 80 NAI folio V, pl. 150; 81 NAI vol. V, p. 74; 82 NAI vol. XVIII, p. 170; 83 NAI vol. XIX, p. 78; 84 LC-USZ62-112273; 85 NAI vol. IV, p. 28; 86 LC-USZ62-105387 (also NAI folio VIII, pl. 281); 87 LC-USZ62-105382; 88 NAI folio IV, pl. 142; 89 NAI vol. VIII, p. 4; 90 NAI folio IV, pl. 128; 91 NAI folio XIX, pl. 669; 92 NAI folio VI, pl. 199; 93 NAI folio IV, pl. 133; 94 NAI folio III, pl. 82; 95 NAI folio VI, pl. 200; 96–97 LC-USZ62-101185 (also NAI vol. V, p. 86); 98 NAI folio VII, pl. 234; 99 NAI folio VII, pl. 242; 100 NAI vol. VII, p. 46; 102–103 NAI vol. XIII, p. 470; 104 LC-USZ62-79772; 105 LC-USZ62-52477; 107 NAI folio XVIII, pl. 634; 108–109 NAI folio VI, pl. 215; 110 LC-USZ61-2088 (also NAI vol. VIII, p. 24); 111 NAI folio VIII, pl. 256; 112 NAI vol. VII, p. 68; 113 LC-USZ62-98071 (also NAI folio VII, pl. 235); 115 NAI folio XII, pl. 405; 116 l. NAI folio XII, pl. 415; 116 r. NAI folio XII, pl. 414; 117 LC-USZ62-88309; 118 t. LC-USZ62-112224; 118 b. LC-USZ 62-112226; 119 t. LC-USZ62-97088; 119 b. LC-USZ 62-48379; 120 LC-USZ63-85415 (also NAI vol. XII, p. 142); 121 NAI vol. XII, p. 136; 122 LC-USZ62-97071; 123 NAI vol. XII, p. 156; 124 NAI folio XII, pl. 424; 125 LC-USZ62-83960 (also NAI folio XVII, pl. 608); 126 NAI folio

XVI, pl. 571; 127 NAI folio XVI, pl. 544; 128–129 NAI folio XVI, pl. 573; 130 NAI folio XVI, pl. 564; 131 NAI folio XVI, pl. 565; 132–133 LC-USZ62-112230; 134 LC-USZ62-115816 (also NAI vol. XVII, p. 56); 135 NAI vol. XVII, p. 52; 136 NAI folio XVII, pl. 592; 137 NAI vol. XVII, p. 54; 139 NAI folio IX, pl. 326; 140 LC-USZ62-101261 (also NAI vol. XIII, p. 28); 141 LC-USZ62-110506 (also NAI folio XIII, pl. 436); 143 LC-USZ62-90801 (also NAI folio XI, pl. 365); 144 NAI folio IX, pl. 304; 145 NAI folio IX, pl. 299; 146 NAI vol. X, p. 90; 147 NAI folio IX, pl. 303; 148 NAI folio VIII, pl. 284; 149 NAI folio VIII, pl. 274; 150 NAI folio XI, pl. 376; 151 NAI vol. XI, p. 58; 152 NAI vol. XI, p. 54; 153 NAI folio XI, pl. 382; 154 NAI vol. XI, p. 76; 155 NAI folio XI, pl. 395; 156–157 Flury; 158 NAI vol. X, p. 162; 159 NAI vol. X, p. 176; 160 NAI vol. X, p. 230; 161 NAI vol. X, p. 228; 162 NAI folio X, pl. 358; 163 NAI vol. X, p. 232; 164–165 LC-USZ62-52200 (also NAI folio X, pl. 337); 166 NAI vol. X, p. 242; 167 NAI vol. X, p. 194; 168–169 NAI folio X, pl. 343; 170–171 NAI folio XI, pl. 397; 172 NAI folio X, pl. 329; 173 NAI folio X, pl. 334; 175 NAI folio XX, pl. 694; 176 NAI vol. XX, p. 80; 177 NAI vol. XX, p. 54; 178 NAI folio XX, pl. 716; 179 LCUSZ62-107281 (also NAI vol. XX, p. 204); 180 t. l. UW 2805; 180 c. r. LC-USZ62-66633; 180 b. r. Flury; 182 t. Flury; 182 b. l. UW 147; 182 b. r. UW 152; 184 t. Flury; 184 b. UW; 187 l. UW; 187 c. UW; 187 r. Flury; 190 Flury;

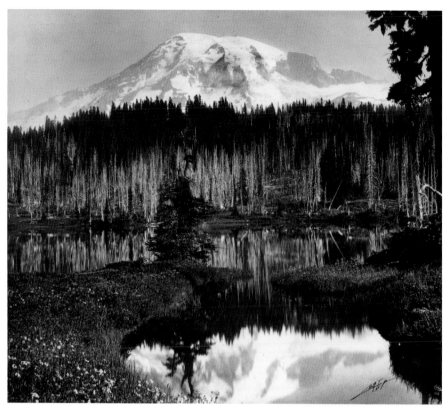

Mount Rainier, ca. 1897
One of Curtis' lesser-known landscape
photos, subsequently printed as an
"orotone"

Mount Rainier, ca. 1897
Eine eher unbekannte Land-
schaftsaufnahme, die später als
»Orotone« gedruckt wurde

Mount Rainier, vers 1897
Un des paysages mal connus
de Curtis. Le virage à l'or a été
effectué ultérieurement

Captions of the portfolio

Bildlegenden des Portfolio | Légendes du portfolio

Front and back cover:
White Shield – Arikara

© 2001 TASCHEN GmbH
Hohenzollernring 53, D–50672 Köln
www.taschen.com

Edited by Hans Christian Adam, Göttingen
in collaboration with Ute Kieseyer, Cologne

Design: Lambert und Lambert, Düsseldorf
Cover design: Angelika Taschen, Cologne

Text editing and layout: Ute Kieseyer, Cologne
English translation by Malcolm Green, Heidelberg
French translation by Catherine Henry, Nancy

Printed in Italy
ISBN 3–8228–5508–1 [German]
ISBN 3–8228–1353–2 [English]
ISBN 3–8228–1354–0 [French]

"Buy them all and add some pleasure to your life."